SARAH LISS

ARMY OF LOVERS

A COMMUNITY HISTORY OF WILL MUNRO,
THE ARTIST, ACTIVIST, IMPRESARIO AND CIVIC HERO WHO BROUGHT TOGETHER TORONTO'S CLUB KIDS, ART FAGS, HARDCORE BOYS, DRAG QUEENS, ROCK'N'ROLL QUEERS, NEEDLEWORK OBSESSIVES, LIMP-WRISTED NELLIES, STONE BUTCHES, NEW WAVE FREAKS, UNABASHED PERVERTS, PROUD PRUDES AND BEAUTIFUL DREAMERS

COACH HOUSE BOOKS, TORONTO

first edition

Published with the generous assistance of the Canada Council for the Arts and the Ontario Arts Council. Coach House Books also acknowledges the support of the Government of Canada through the Canada Book Fund and the Government of Ontario through the Ontario Book Publishing Tax Credit.

LIBRARY AND ARCHIVES CANADA CATALOGUING IN PUBLICATION

Liss, Sarah, author
 Army of lovers : a community history of Will Munro, the artist, activist, impresario and civic hero who brought together Toronto's club kids, art fags, hardcore boys, drag queens, rock'n'roll queers, needlework obsessives, limp-wristed nellies, stone butches, new wave freaks, unabashed perverts, proud prudes and beautiful dreamers / written by Sarah Liss.

(Exploded views)
Issued in print and electronic formats.
ISBN 978-1-55245-277-6 (pbk.).-- ISBN 978-1-77056-353-7 (epub)

 1. Munro, Will, 1975-2010. 2. Gay activists--Ontario--Toronto--Biography. 3. Artists--Ontario--Toronto--Biography. 4. Disc jockeys--Ontario--Toronto--Biography. 5. Gay men--Ontario--Toronto--Biography. 6. Toronto (Ont.)--Biography. I. Title.

HQ75.8.M85L58 2013 306.76'62092 C2013-904229-6

Army of Lovers is available as an ebook: ISBN 978 1 77056 353 7.

Purchase of the print version of this book entitles you to a free digital copy. To claim your ebook of this title, please email sales@chbooks.com with proof of purchase or visit chbooks.com/digital. (Coach House Books reserves the right to terminate the free download offer at any time.)

Dramatis Personae
in alphabetical order

Ryan Auger, a childhood friend

Cecilia Berkovic, friend, artist, designer, caregiver

Benjamin Boles, art-school classmate, first real boyfriend, musician, writer

Dan Burke, notorious concert promoter, sometime addict, garage-rock guru, raconteur

John Caffery, friend, caregiver, Vazaleen go-go dancer, member of Kids on TV

Rori Caffrey, long-time friend, punk

Michael Cobb, U of T professor, queer theorist, caregiver, friend

Mark Connery, artist, punk, activist

Vaginal Davis, legendary performer, musician, artist, genderqueer, lecturer, character

Beth Ditto, lead singer of Gossip

Ewan Exall, friend, punk, music promoter

Joel Gibb, bandleader of the Hidden Cameras, artist, friend, fellow Meadowvale-ite

Andrew Harwood, artist, curator, gallerist, drag sensation

Kevin Hegge, filmmaker, DJ, friend, artist

Lorraine Hewitt, sex educator, punk, Vazaleen go-go dancer, friend

Peter Ho, primary caregiver, boyfriend, confidante

Joanne Huffa, friend, writer, punk, zinester, fellow Meadowvale-ite

Luis Jacob, artist, friend, sometime collaborator

Bennett JP, punk, filmmaker, friend

Bruce LaBruce, artist, filmmaker, pornographer, queer icon

Jeremy Laing, celebrated designer, artist, friend

Maggie MacDonald, sometime Hidden Camera, activist, zinester, performer, punk, friend

Max McCabe-Lokos, musician, actor, friend

Alex McClelland, ex-boyfriend, best friend, queer activist

Saira McLaren, artist, friend, former punk

Lynn McNeill, Beaver owner, former Lee's Palace bar manager and booker, Toronto fixture, gay rock-scene vet

Dave Munro, Will's brother, childhood adversary, lifelong champion, professional tattoo artist

Ian Munro, Will's father

Margaret Munro, Will's mother

Owen Pallett, friend, erstwhile Hidden Camera, occasional Arcade Fire collaborator, virtuosic musician

Peaches, Toronto-born international performer, pervert, queer icon

JD Samson, musician, performer, artist, member of Le Tigre and MEN

Amber Ternus, friend, punk, activist

Lex Vaughn, artist, performer, comedian, friend

'Gentleman' Reg Vermue, Light Fires/Gentleman Reg frontman, drag firecracker Regina the Gentlelady

No Tears for the Creatures of the Night,
a neon installation by Will from 2004

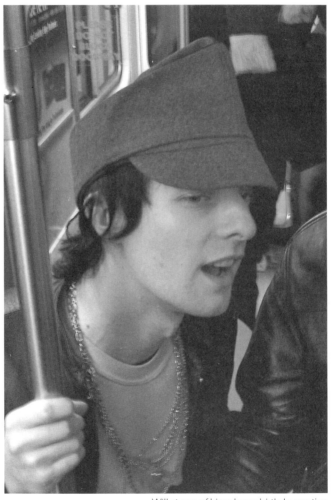

Will at one of his subway birthday parties

No tears for the creatures of the night
No tears
My eyes are dry
Goodbye.
I feel so hollow; I just don't understand
Nothing's turned out like I planned.
 – 'No Tears for the Creatures of the Night,' Tuxedomoon

This is a love letter to Will Munro. As I write this now, it is three years and a month, give or take, since he died at the unfathomably young age of thirty-five from brain cancer.

If you knew Will, this letter is for you. If you didn't know Will, I'm deeply sorry you missed out on meeting him. This letter is even more for you. You may not realize it, but whether you live in Toronto or Berlin or New York or beyond, chances are you've tripped over or passed by or sat in or danced at or made out to the soundtrack of something that exists only because of him.

Will Munro was a great many things – an acclaimed visual artist, a diehard activist, an awesome DJ, a business owner, a party promoter, a tireless advocate for underground bands – but above all else, he was a bringer-together of people, groups and things. This gentle, hilarious guy who looked, I swear, like a ghost-pale whippet, was the bridge between hardcore punk and drag queens, indie-rock and fetish parties, libertines and prudes, youth support groups and textile art. He was a creator, sure, but not just of objects; he created movements and transformation and, most of all, community.

Will was a pioneer in the geographical exodus of LGBTQ culture in Toronto. Certainly there were events happening in pockets outside the Church-Wellesley corridor – the city's hoary, storied Gay Village – before he came along, but he led a charge of queers from the Village into dive bars and rock clubs in the west end of the city, presaging the inevitable march of gentrification and leaving his mark (sometimes literally, tagged on the crumbling brick

of buildings in disrepair) along the way. In his hands, the Beaver, a modest joint that looked out over West Queen West, which at that point could barely be described as a neighbourhood in transition, was transformed from an unassuming brunch spot that served spillover crowds from the nearby boutique hotels into a de facto hub – not only for the queer community, but for a wide swath of both stroller-pushing locals and creative oddballs who chased their late-night booze with mid-morning espresso.

He was a fabric artist, and that medium seemed to inform his approach to everything – he wove, stitched, sewed and appliquéd things together that would never naturally have fused. He brought the sleaziest roadhouse rock into his monthly queer party, Vazaleen (originally Vaseline, until accusations of copyright infringement got in the way), which he launched in January 2000, and which was itself a novel bridge-building exercise that brought lesbians, gay men, bisexuals, transfolk and genderqueers together under one roof. In an interview in 2003, Will explained the rationale behind his parties. 'Everything I do in nightlife is a critique of mainstream gay nightlife,' he said. 'We need a space that's not exclusively gay white men. We need a space where our straight friends can hang out. We need a space where cool, interesting people can mingle, get down, network, have sex, get dressed up. I gave it a good chance, but neither gay nor straight nightlife culture gave that to me.'

For a time, Vazaleen was the most idyllic, perverse, anything-goes community love-in you could imagine. My memories of most of these parties are admittedly hazy, but I can vouch for the energy inside Lee's Palace when 'Fox on the Run' or 'Fuck the Pain Away' or 'Jet Boy, Jet Girl' was playing, and weird, blurry porn flickered on the walls, and Will was wearing a chicken suit, or a Limp Wrist T-shirt, or a little boy's school uniform, or that peaked grey-wool cap he always wore, and smiling beatifically while a motley crew of weirdos bobbed for butt plugs. Will dreamed up Vazaleen at a time when gay parties were all about circuit house, and lesbian parties barely existed. Mixed crowds, especially ones that managed to welcome not only a wide spectrum of gender, but also race and class, were as common as unicorns.

Among Will's great gifts was his uncanny ability to combine activism with hedonism, to fuse edification and unabashed, over-the-top revelry. That might not sound like such a big deal, but it was, and is, for a bunch of reasons: traditionally, queer culture is not something that's been exceptionally well documented – it's challenging to keep track of a cause and a group that, until recently, was stigmatized and forced underground. Will seemed driven by a desire to share our collective history, and he did so in all his work. By quietly championing the idea that a diverse group of LGBTQ people simply coming together en masse at a nightclub could have political undertones, he kept the spirit of radical liberation alive at a time when the more revolutionary aspects of taking over space by and for freaks had been lost on – or dismissed by – the larger and more visible sectors of the movement. And yet he also created an environment where you never felt belittled for your personal beliefs.

You could chat, for instance, with same sex–marriage activists while local gay indie-folk band the Hidden Cameras played 'Ban Marriage,' a catchy critique of what they viewed as a conservative institution. Fresh-faced trans kids could safely talk about getting bashed for not passing, while, inches away, thirtysomething lesbians debated the merits of known versus unknown sperm donors and traded bondage tips. Stoic dyke cops clutching sweaty beers could take swigs and discuss class conflicts with the anti-poverty punks they'd recently intimidated at a rally – and most of the time, no one would come to blows. These exchanges were defined by an atmosphere of mutual respect.

The beauty of the spaces Will cultivated lies in their tendency to expose people to a host of different perspectives and spark the open discussions that can shift even the most embedded beliefs. Without them, the range of queer identities sometimes becomes distilled – in the media and within the subculture itself – to an inane dichotomy between 'good gays,' who strive for socially permissible forms of equality, and 'bad gays,' who cling to the bacchanalian practices left over from the disco era. The reality, which Will knew, is that there are way more than two, or even fifty, shades of gay.

In 2012, the Art Gallery of York University mounted a mammoth exhibition of Will's work, appropriately titled *History, Glamour, Magic*. Many visitors commented on the display of Will's trademark reconstructed Y-fronts, which hung like strings of hopeful Buddhist prayer flags across the gallery's cavernous ceiling. I loved the undies, but what gave me goose bumps was gazing up at a giant wall of screen-printed posters for Will's many events – from Vazaleen to Moustache (an amateur striptease night at the male strip club Remington's) to Peroxide (a sweaty electro night in Kensington Market, a neighbourhood known for its international food stalls and second-hand clothing shops) to No T.O. (a heady celebration of No Wave music) at the Beaver – and thinking, *This is our youth*. By that, I don't simply mean to reflect upon one particular cohort of late-twenty- and early-thirtysomethings – that wall of posters documented a particular coming-of-age experience for Toronto's queer community as a whole.

'The connections between young and old people in terms of talking to each other and sharing knowledge, they're eroding,' Will told me in 2003. 'Instead, it's all about fucking. That's great. That's fine. But if you don't have anything else, then what's gonna happen to our culture? Is our culture gonna become *Queer as Folk*? How can you look to the future if you don't know the past?' Crowds at all these events, but especially Vazaleen, were made up of people who ranged from eighteen to seventy-eight years old, and that collision between generations was crucial to both the energy at Will's parties and his investment in making sure LGBTQ history was kept alive.

This book is meant to capture a galvanizing moment in the evolution of the city and its subcultures by sharing the story of a kid who became an icon because he wanted to share the stories that moved him. We were barely more than friendly acquaintances, but I loved Will, and I feel as committed to keeping his history alive as he was to ensuring the memories of his forbears didn't fade away. Revisiting the changes he brought about was an intense, rewarding nostalgia trip for me, but the process was

driven by a desire to share Will and what he did with a generation that spills outside Toronto's city limits, whose members missed out on experiencing that brilliant, bracing sense of community.

Toronto still has brave and crazy punk-rock lovers who book shows with left-field weirdos knowing full well they'll lose money every time. There are kids doing drag, kids invading public space, kids dressing up and throwing parties. Just as I started to work on this book, several remarkable things were happening: in the summer of 2012, the Ontario legislature passed Toby's Act, a bill to codify the rights and protections of transfolk under the Human Rights Code. Brave, self-possessed LGBTQ youth faced off against the musty homophobes in the Catholic Church in their protracted fight – first to be allowed to have Gay-Straight Alliances in Catholic schools, and then to be able to call those groups by their rightful names. Glimmers of Will's spirit are alive when enterprising queens go all out with their outfits for Hot Nuts, an insane, mixed drag night, and when upstart collectives throw parties that are a priori inclusive and invested with history. An award in his name, given annually by the helpline at which he volunteered for many years, goes to a queer youth, or a queer youth organization, that encourages community growth through the arts. There is a fund in his name too, intended to provide support to queers living with cancer. Still, the idea of Will himself can be a question mark, even to those who were lucky enough to lose themselves on a dance floor while he manned the DJ booth.

There's a memorial for Will in Trinity Bellwoods, a sprawling, grassy park in downtown Toronto. Near the south end of the dog bowl, slightly west and due north of the main gates, you'll find a young tree and a plaque with his dates of birth and death, and a simple inscription: 'An army of lovers will never be defeated,' a seventies-era slogan derived from a poem by lesbian-feminist writer Rita Mae Brown, and a motto for the way Will lived his life. The original army of lovers lived in ancient Greece. Known as the Sacred Band of Thebes, it was revered as the most fearless, elite battalion at the time; its members were all men who loved men, a sissy squadron for whom Don't Ask, Don't Tell would've been an absurd joke. The army of lovers who participated in this

book was equally fierce, if less combative: I was lucky enough to find legions of storytellers with limp wrists and raised fists to help piece together a fallen fighter's life and work. Will's story wasn't mine to tell – like so many things in his life, it was a collective effort. Inevitably, like so many collective efforts, some voices are louder than others; others still were drowned out, or went unheard along the way. Some of those closest to Will demurred; their memories of him were still too fresh and painful to be offered up for human consumption. So there are still countless stories to tell about this man who made his city a better place, and I hope they get heard by many sets of ears. This book is not an obituary, but a reminder of what we've lost, and an appeal to do better, to band together, to remember his name.

This is a love letter to Will Munro, and a rallying cry for his army of lovers.

Part I
Mississauga Goddam

Mississauga goddam / Bears the treachery of my own man
I'll be wearing my disguise / Until I rid my life
Of Mississauga goddam
Mississauga people / Carry the weight of common evil
And go about their lives / With a whisper and a whine
About Mississauga goddam.

 – 'Mississauga Goddam,' The Hidden Cameras

People couldn't stop talking about his underwear. It's understandable; who'd expect the seeds of revolution to be sown (and sewn) in a pair – hundreds of pairs – of stained, stretched-out Y-fronts? But for Will Munro, briefs were both a medium and a muse, the raw materials of his work and the rich, earthy ideas that underpinned his art, replete with faint traces of the asses that had come before his hands had grazed those elastic waistbands. In 1997, at twenty-two, Will and his undies drew the ire of conservative blowhard Michael Coren, who raged and sputtered in right-wing rags and on talk radio about this young pervert's art-school thesis project: banners and curtains and walls made from reconstructed 'boys' underwear.'

Exactly two decades earlier, Gerald Hannon, a writer and journalist and eventual gay icon, scandalized uptight Toronto with his article 'Men Loving Boys Loving Men' in *The Body Politic*, a pioneering, collective-run, queer Canadian magazine. The sympathetic account of intergenerational sexual relationships profiled a trio of older men with a shared penchant for hooking up with fresh-faced youth. To mainstream readers, Hannon – and the publication – were promoting pedophilia. A string of breathless, outraged articles appeared in the *Toronto Sun*, and in January 1978, two months after Hannon's story was printed, Pink Triangle Press, the publisher of *The Body Politic*, was charged with distribution of 'immoral, indecent or scurrilous material.' It took over five years (including a retrial and several appeals) for the case to ultimately be decided in *The Body Politic*'s favour.

So all those years later, there was a certain air of déjà vu when Coren called on tasteful Torontonians to express their disgust with a gay student's allegedly tasteless art exhibition by storming the gallery with dirty diapers in hand like pitchforks. How could underwear be art?

It could be, and it was. And in the end, the pundit's family-values offensive had the opposite effect of his desired outcome: nobody showed up with nappies, and Will Munro established himself as one of the most promising stars of the city's art scene, a kid who had something to say (about sex, queerness, masculinity, beauty, filth) and a way of saying it that was both unconventional and compelling.

Will's much-discussed undergarments weren't merely a salacious gimmick – they exposed his roots, his desires and his psyche, telling the story of a fastidious suburban misfit who fell in love with other boys, crafts, skateboarding and punk rock (in that order), and shed his inhibitions when he bolted for the big city. In one interview from 1999, he attributed his fascination to childhood deprivation: he'd yearned for Underoos, with their vibrant patterns that mimicked the costumes of superheroes and cartoon characters, and received plain, white Y-fronts ('They felt clinical and sterile … and repressed') instead. As a teenager growing up in 1980s Mississauga, not entirely closeted but still evasive about his sexuality, he swiped a pair of briefs that belonged to a hardcore boy with whom he was enamoured, and kept them as a fetish object. And before he made a break for Toronto, Will coerced other skater dudes he knew to drop trou and pose for Polaroids, only to boldly out himself as their likenesses formed through a murky haze on the film.

The kid was more than his Hanes, though. Underneath it all, he was Minor Threat, J.D.'s, mock ribs, skull sweaters and hand-beaded breastplates. He was a crisis counsellor, a line cook, a skilled seamstress, a roller skater, a drag diva, a cheapskate and a drama queen. He was hardcore, homocore, queercore, straight-edge, feminist, anti-assimilationist and, at times, a vaginaphobe. He was a chatterbox who struggled to express his own emotions. He was a music fanatic who couldn't hear properly, being deaf in

one ear. He was driven by a desire to understand his own history, to keep the past alive in an age of ephemera and celebrate and share those impulses through conversations with others.

Here's where all of that came from.

Margaret Munro (mother): Will was born in Australia and lived there for about three months, and then we travelled home via New Zealand and Hawaii. He was not a good traveller. Will was also premature by a month. And because he was premature, he had breathing problems. He also – we learned when he was seven or eight – had a hearing problem, which stemmed from being induced. He was prone to asthma, and he ended up getting sick in New Zealand. We'd hold the kid's head over sulphur to allow him to breathe. It was very difficult, because he and David were only eighteen months apart, so we were travelling with two young ones.

Dave Munro (brother, childhood adversary, lifelong champion, professional tattoo artist): We were a year and a half apart – I'm older. About six months after Will was born, we moved back to Canada, just outside Montreal, to a suburb called Valois in Pointe-Claire. The house we moved into was my grandfather's house. My folks had bought it off of my grandparents. It was a nice house on

Will (left) and Dave at home

Queen Avenue, with a double lot and this big backyard. There was a little horrible pseudo-stream, which was more of a sewage line, behind the house. In 1980, we moved to Mississauga.

Ian Munro (father): The kids hated Mississauga. We finally ferreted out that they were looking for the same type of community we had left, something that had started as a summer retreat. A lot of those houses, they were still some of the originals of summer camps that got updated and insulated. There were giant trees and large properties.

Margaret Munro: In Pointe-Claire, there was a women's centre. The women got together and the kids got in another room and did all kinds of crafts. The kids all got together afterwards as a group, and we used to go camping together. When we moved up to Mississauga, which was really different, it took a year for the kids to feel like they belonged there, even on the street. They got along with the kids on the street, but they didn't have a whole bunch of friends. It was very difficult.

Dave Munro: Will was kind of sheepish as a kid. He was very quiet when he was younger. He was a very normal child, generally – he wasn't a kid that was burning cats. He modelled his notions of how he was going to move forward at a very early age on the good side of Boy Scouts, on Alex P. Keaton from *Family Ties*. He wanted monogrammed sweater vests. He wanted a briefcase. The first record he owned was *Hooked on Classics*. That anal-retentive side of him never left. And through that, he developed the need for acknowledgement. In a large public school system, no teacher can focus on any one student – there are too many students, and half of them are fucking assholes. And when that falls away, what do you do to get the pat on the back? Especially if you're not getting it at home, which was something that didn't happen a lot.

Ryan Auger (childhood friend): I met Will through our family friends when I was around eleven at a Scouts community picnic. Will was easy to spot because, where other boys had perhaps three or four

badges, Will literally had no room on his big red sash for even one more badge. He must have had 150 all up – I was certain they would start sewing his next row to his forehead. It's important to note that Robert Baden-Powell didn't just give these things away – each one required, on average, about 100 hours of work and a fairly robust little test to gauge your proficiency.

Dave Munro: Goal-oriented is one way of describing Will and his sash. He liked the visual acknowledgement of achievement.

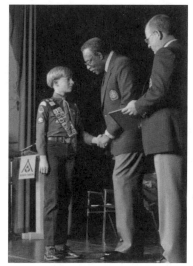

Will being given the Chief Scouts Award in 1988 by Ontario's Lieutenant General Lincoln Alexander

Ryan Auger: When I joined the same Scouts group as Will the winter after, there was a buzz about the place because Will was going to represent our humble little pack (2nd Streetsville) at the 16th World Scouting Jamboree in Sydney, Australia.

Margaret Munro: Normally you went into scouting at thirteen; at age twelve, he rewrote the scouting book and presented it to his leader, who was a friend of ours. He was fourteen when he became a Queen's Scout, which is when you've gotten all your badges. He was the youngest one to become a Queen's Scout.

Dave Munro: One time, he wound up meeting the Lieutenant Governor of Ontario, who was handing out these dipshit awards. We had to go to some bad church in Brampton. It was just one of those things. My folks thought it was an achievement. My father was heavily involved with scouting, and if you wanted to do

anything else outside of scouting, you'd fucking go to Scouts. The one bright side is the odd collection of people who are usually involved in these kinds of things. We had some fairly cool parental figures. Half of them were survivalists. They would dump you in the woods: 'Here's a Swiss Army knife, some matches and a tarp. We'll see you in three days.' I was really into that aspect of it, like, 'All right, I'll go get drunk in the woods.'

Ryan Auger: Will was top of the heap in our little word of adolescent awkwardness, but even at that age, he carried himself with a calmness and selflessness that prevented any suggestion that he needed to be taken down a peg. He really did have a quiet presence that attracted people to him – when he spoke, he was usually more thoughtful than his peers, and he had this subtle way that demonstrated to others that he'd already figured it out. He was a slight kid – no athlete, not a big personality, not especially funny, but still, he had this gravitas that made others stand up and take notice.

Dave Munro: The household was tumultuous at times. It could be very violent, and it was definitely verbally aggressive. When we were younger and living in Montreal, my dad was terrifying. Our folks are supportive, but it could be a very aggressive house. I would leave. I'd pop back up at three in the morning or something like that. At a very young age, probably by ten, I was already doing that, but Will would stay. We had an argument once about who had the rougher childhood. He was like, 'You're a fucking dick. You weren't there for the fucking anger.' And I'm like, 'Oh yeah, I kind of left you behind, didn't I?'

Margaret Munro: Our house had an open door, and that's where some of Will's approach to people came from, I think – helping people. I remember the kids going, 'If somebody's in trouble, they can come and live with us, right?' I said, 'What?' And they go, 'Well, you did that. You brought people into the house. So we can do the same thing.'

Dave Munro: Will was the kid who stayed after school and did extra projects. He cleaned the chalkboards; he'd be left in charge of the room when the teacher stepped out. There was a very adversarial nature between us because of it. If I got busted, it was because he turned me in. And that was generally how he handled things. He would periodically try to blackmail, but that wouldn't work out so well, because physically I've always been two of him. There was a push-comes-to-shove situation that would always happen between the two of us, especially when we were younger. Part of it would've been due to the aggressive nature of our household. And the area was kind of violent. You had the subtle violence of the quietness that happens inside houses with kids getting beaten. And these kids fought a lot. It was not unusual for you to be coming home and get chased by eight people. Though it had all the wonderful residuals of the suburbs, the neighbourhood also had that really horrible underbelly as well.

Joanne Huffa (friend, writer, punk, zinester, fellow Meadowvale-ite): These days, Meadowvale has a billion big-box stores, prefab mansions and condos. Back then, there were still lots of fields surrounding the subdivisions, Meadowvale Town Centre and the two manmade lakes that were the nature features of Meadowvale. The population was mostly families and fairly white, but became increasingly diverse every year. Joel Gibb of the Hidden Cameras also grew up in Meadowvale, and his song 'Mississauga Goddam' speaks volumes about our old suburban home.

Margaret Munro: David was a lot more outgoing, Will was a little more introverted. It may also have been his hearing condition. He became very good at lip-reading, and the funny part is that when he did get a hearing aid when he was seven, he came home from school and said, 'The teacher said we were in a noisy classroom because we're above the furnace, and I always thought she was just crazy. But it *is* noisy.'

Alex McClelland (ex-boyfriend, best friend, queer activist): He was totally in denial about his hearing problem. He used to have to

wear a hearing aid in school, and he just stopped wearing it. I don't know many people who are functionally half-deaf and fake going through life. He was really good at doing that, and he'd miss so much. He had one good ear, and if he cared, he would turn to you so he could hear you, and would be good at making people think he knew what they were saying. So he missed a lot of stuff.

Dave Munro: His hearing aid was regularly found in garbage, 'accidentally' on the bottom of his foot. That thing would be fucking put in sandwiches. My folks would ask the teachers to make sure he had it in his ear, which of course just brought more attention to it. A hearing aid doesn't just make people louder; it makes *everything* fucking louder. Chewing. You can hear yourself breathe. It's the most annoying thing in the world. Will learned how to recognize octave changes to see if he was in trouble – which is also why his pitch would change so drastically when he was speaking – and he made a point of looking at people when they were talking to him, which a lot of people don't really do in conversations. People were like, 'He really looked in the eyes when he was speaking to me.' Uh, no, he *had* to. Otherwise, he'd tell you what time it was. That was his go-to when he didn't hear you. And he never wore a watch, so he never gave you the right time.

Margaret Munro: The teachers would always comment that Will and Dave were really different artists, very incredible artists.

Ian Munro: It was all art, all the time. Education and the rest of it was just stuff that had to be done. But where Will really flourished was in the various art classes. Needless to say, he had a whole bunch of art teachers in love with him.

Dave Munro: I got into art because it attracted attention, and Will got into art because of me. We spent a lot of time in the car, so we spent a lot of time drawing stuff. There was a neighbour who was super sketchy and really scary. We were playing nicky nicky nine doors at his house, and he caught Will and literally grabbed him by the throat and picked him up. Scared the living piss out of

him. I freaked out and ran to get my dad to save Will. By the time we came back, I guess the guy had realized he had gone way too far. This guy made ducks, handmade loons and mallards, and he offered to show Will how to build ducks. Will made this loon. Even to this day, it's really kind of incredible. He was probably nine when he made it.

Ian Munro: At the daycare, the after-school programs, William and David were the only kids that didn't fight, particularly siblings. They called them the little old men, because they sat and talked and sorted out their problems. The big one ended up being the bodyguard for the little one. The little one did tricks in high school like going down the hall and pinching the football team's bums. And David would have to run after him and try to protect him. But one time, this guy had set David up for a fight after school, and the only person who didn't know about it was David. There they were facing off, and out of the crowd comes William, and he walks right up into this guy's face and says, 'You leave my brother alone,' and was able to double right up and punch him, because nobody paid attention to William. I'd been saying to David, 'Don't pick on your brother, because one of these days he's going to punch your head off.' Well, it wasn't David's head that got it first. I don't think to this day David has lived it down: 'My kid brother, a foot smaller, a lot lighter, gentle child, fought for me.'

Dave Munro: Through most of our growing up, my father was unemployed. My mother was carrying multiple mortgages on the house. Our cousins were living with us. There were health issues with my mother's parents, so she was travelling back and forth from Montreal regularly. That woman carried the fucking world on her shoulders and then some. She came from a very violent and abusive household. The coping skills you'd need to contend with those levels of stress, I can't even fathom. A lot of my mom's elderly family members — her aunts, her father and her mother — they all died in a three- to four-year period. It was a huge blow, mixed with everything else that was fucking exploding around her. She went on a sort of soul-seeking thing. By then, we were

starting into our teens, and things were starting to become severely unhinged. I was drinking all the time. By the age of eleven, I rarely drew a sober breath. Will, on the other hand, was the guy who cleaned up after the colossal messes I would make.

Margaret Munro: David got into booze, and Will was trying to tell us, and we weren't listening. That was one thing I don't think Will ever experienced or experimented with. He had a hate for booze and drugs, and was just not going there.

John Caffery (friend, caregiver, former Vazaleen go-go dancer, member of electro-punk trio Kids on TV): His dad had been a drinker for a while, and pretty early in life he made a decision that that wasn't for him. He was always straight-edge.

Alex McClelland: During his childhood, and when Will was a teenager, he told me that his dad would disappear for really long periods of time. Originally, Will said, they thought his dad was having an affair. Then later, they figured out his dad was sitting at the local Tim Hortons for hours on end talking to strangers. His dad was probably depressed. But Will remembered his mom telling him to call the Tim Hortons to ask the staff to tell his dad to come home so they could have dinner together, because otherwise his dad would just stay there.

Dave Munro: In Grade 6, or it might have been the summer before Grade 7, Will changed. It was an overt change. By then, me and my friends were already a couple years into skateboards. And, being Alex P. Keaton, he had very adverse feelings about that. We weren't furthering ourselves socially. We weren't going to fit in. 'You'll never be a good parent.' These are the

kinds of comments that would come out of his mouth. One day, he swiped a skateboard. Quite literally, there's five of us and four boards, and we're like, 'What the fuck?' And we go out and there he is, heading down the road, back and forth on the skateboard. The next thing was that he picked up a Minor Threat record – *Out of Step* – and all of a sudden that was it. That was the change, almost to a day. Will was like, 'Fuck doing after-school programs,' and started down his own path.

Ian Munro: Skateboarding like crazy. He had one or two or more skateboards he'd decorated. Of course, they used to swap them and find different trucks and wheels. They used to repaint them.

Margaret Munro: He worked at McDonald's for a long time, and then he ended up at the Keg. It was really funny because when he was working at the Keg, he used to do the salad bar, and he'd decorate it. One of the people who owned the place got really annoyed with him and told him, 'Stop that.' And then the patrons complained – they wanted it back!

Ian Munro: He used to carve potatoes. He made art out of the cheapest thing you could find in a big kitchen. The only time I was at the Keg, I went to see the salad bar and his creations, and that was the time he had been told not to do it. About two days later, after the weekend crowd, he said, 'I'm carving the potatoes again, Dad, if you want to come see them.' Inevitably, he got to rub it into the manager's nose.

Joanne Huffa: I was at Meadowvale Secondary before Will. I think Dave was in Grade 9 the year I was in Grade 13 (1988), but from what I can tell, things were pretty similar. There were lots of different cliques. I had friends in the new wave/proto-goth group, but my own friends were nerdier, mostly band kids and wannabe writers. Our group wasn't as cool (to me) as the kids who wore all black and took acid on the weekends, and we weren't the jocks, the preps, the breakdancers or the kids who spent Friday nights studying. We spent most of our Friday nights downtown

at *Rocky Horror* and, if we could, we'd be back downtown on Saturday shopping for vintage clothes and records.

Dave Munro: I started going to shows in '87. Will was probably about fourteen when he started going to shows, around 1989. It was a big deal because we didn't have access to a car. So if you were going to go downtown and see a band play, odds are you were going to be camping out downtown. It was two and a half hours by subway and bus to get to our neighbourhood, and then the transit to that area stopped after 10:30 p.m. Being Toronto, no band was even onstage by 10:30. You'd find a park to stay wide awake in. I'm sure if the parental units were half-aware of what we were up to at the time, they'd be like, 'What the fuck?' We would've been condemned.

Margaret Munro: They couldn't figure out how we figured out what they were up to. We could always hear them through the vents. And you know, it was really, really funny, because they were just like, 'How did you know what we were doing?'

Dave Munro: In the mid-eighties, skateboarding wasn't popular. There were probably about ten or twelve of us in a school of 1,500 that rode skateboards. There were even less who were interested in punk and hardcore music. But at the same time, you became very tight with those who were there, no matter what collection of douchebags they were – and they were fucking assholes! Half of them were in and out of jail or juvie. A lot of these kids – they were the periphery, they were the riff-raff. Will would be a part of it, but he'd go his own route as well. I think some of it maybe tied into a couple of kids who did skate he thought were cute.

Alex McClelland: The first way Will kind of explored his sexuality was that he learned how to tattoo using his brother's equipment, and he'd offer skater boys in the neighbourhood tattoos for free if he could take naked pictures of them. People would be into it.

Dave Munro: He definitely wasn't out of the closet at that time. I don't know if he had fully figured it out. According to him, he supposedly figured it out quite young. On the street behind us, there was a kid who Will had his first crush on when he was really young, like six or seven. They would have sleepovers, and it was a giant underwear party – which tied into so much later on!

Alex McClelland: Will always said that he was never not out, because he had his brother at his school so he was just himself. His brother is an enormous tattooed guy who would kick the shit out of people for him. And Will would go to hardcore shows and was a skater, so I think he was kind of safe.

Dave Munro: Generally, people really liked Will. But he got into a thing in high school where he started pinching football players' asses all the time. They'd say, 'Your fucking brother's acting like a faggot.' 'So?' 'I'm just saying.' 'Are you done saying it?' 'Yeah, I'm done saying it.' It would end there. Growing up in the punk scene, you tended to be around people of like minds. So if someone was going to call you out, there were usually a couple of people who were just as likely to stand by you if it wasn't going to go that way.

Alex McClelland: Will said he'd seen his brother get really drunk and be a jerk and an asshole. He did try to drink a few times, but I think what had happened is he was scared that, if he drank, he would hit on the boys that he liked in Mississauga. He was never straight-edge for political reasons, I don't think. He was straight-edge because he was scared of losing control.

Dave Munro: There was a lot of pressure to date, of course. And Will was an attractive kid, so girls would be quite pushy about him spending time with them, which he would do, even though

he lacked interest. There were maybe three or four girls in high school that Will even cared about being around, at all. Mostly, it was people who had an affinity for sugar. We were bored suburban kids. 'You want to set that garbage can on fire?' 'Yeah, let's set the garbage can on fire.' There wasn't a lot to do. You rode your skateboard, you hung out with assholes and you did stupid shit. That was about it.

Rori Caffrey (long-time friend, punk): Will said that when people had questioned him about his sexuality in high school, he would deflect it by saying silly and pretentious things like 'I have no interest in sex. It's so messy,' or 'Oh, I'm only attracted to furniture.' He told me a story about walking home from school one day with a female friend who he figured was harbouring a huge crush on him. Out of nowhere, she made the big move and swooped in and kissed him on the mouth. It might have been his first kiss. I asked him what happened next and he seemed embarrassed. He admitted that he was so overwhelmed by it he simply walked away without saying a word.

Ian Munro: I was absolutely blind to the fact that Will was gay in high school. I have to carry the burden of ruining part of his life because I grew up supposedly homophobic. I was given my straight instructions – not good, not bad but not good. Like I said, everything I know I learned by the time I was six years old. It wasn't until my children corrected me that I learned different. I apologized.

Dave Munro: When I was seventeen – Will would've been fifteen – my mom hit a wall with the succession of troubles and traumas she'd been going through. She finally decided to go see a therapist. After the second or third time that she and my dad had gone, they called us downstairs and apologized to me and Will for our childhood, which was very weird. They were both crying, and they were like, 'If you want to see a therapist, we'll pay for you guys to see a therapist. From what we know of your childhoods, you need to see therapists.' And then Will and I started – well, not really apologizing, but we were basically like, 'Look, you did

what you did because of where you came from. We've learned from your experiences and our experiences and hopefully we're not going to do the shit you did.' That drastically changed the dynamic in my family.

Ryan Auger: Will and I ran in very different circles in high school, but always got along, given we'd known each other since we were kids. From around Grade 10 onward, Will really started to separate from the pack, a dangerous thing to do in the über-conformist, Anglo, middle-class suburbia where our school and community was located. Will sat behind me in biology, and one time a bloke started to rip into Will because Will had come to school having clipped his fingernails to a point: a bit avant-garde, perhaps, but part of a package of eyeliner, big boots and chains, etc. – that was Will's style at the time. What's most notable – and why this stands out in my mind – was Will's reaction. He sat there calmly, and simply asked one disarming question after another: 'Why does this bother you so much? How does it make you feel when you look at me? Is it hurting you that I've chosen to look this way?' It was really an extraordinary exchange, leaving the antagonist more than a bit confused and embarrassed, and showing that Will really did have that gift of cutting to the core of people's psyches.

Joel Gibb (bandleader of the Hidden Cameras, artist, friend, fellow Meadowvale-ite): I never talked to Will in high school. I saw him a couple times wearing bondage trousers – plaid pants with a leather strap between the knees – and thought of him as this cooler kid, and then he was gone. He really was a symbol of hope, because the high school was terrible.

Amber Ternus (friend, punk, activist): Will was part of the straight-edge scene in the suburbs, and that was his gateway into living free and being part of an alternative culture. Certainly when I knew him, he was 100 percent out, and I don't think he ever really managed to be a straight guy at school. Although the punk scene was extremely straight at the time, and there was very little gay influence at all, he still managed to find a sense of community

there. It was definitely punk first, and his brother was obviously a huge influence, because he was older and included Will in stuff. That was his first love: the live music, being able to go to shows and just lose himself in it. But because he was so queer and so out there and even his regular fashion was a little bit more eccentric, he stood out a little bit in the straight-edge scene.

Ewan Exall (friend, punk, music promoter): I probably saw Will for the first time at the Niagara Café in the winter of 1991–92. That was where the DIY punk shows happened downtown at that time. At that point, Will tended to just tag along with his older brother. I had a nodding acquaintance with Dave at first and then we started talking when we ran into each other – the first time we actually spoke was at Rudy's Skatepark in Mississauga. We used to bowl and ramp skate there, as well as see bands like Chokehold and Snapcase. Will was definitely a striking-looking man from a young age, and very obviously Dave's brother – they both have a strong resemblance to their mother – but he was slight and small, whereas Dave was always a big fucker.

Rori Caffrey: The first time I saw Will was in Ottawa, and there had been a hardcore show that a few carloads of punk kids from Toronto had travelled up for. I was walking up the street with my friend Elizabeth, and she was complaining that she wanted a boyfriend, but there were no cute, single guys in the Toronto punk scene. Just as she was saying this we were across the street from this punk house where a bunch of kids, including Will, were hanging out on the front porch. My gaze immediately fixed on Will. I've never said or thought this about anyone else, but he had an aura glowing around him. I don't remember a single other person who was on that porch, or what the weather was like that night, but I do clearly remember seeing Will smile. I turned to Elizabeth and said, 'No cute punk guys? What about him?' She said, 'Oh, that's Will! He's gay. I so wish he wasn't.'

Dave Munro: Going to shows made it a little easier to come out. For those around him, there was no official 'I'm out.' It was just,

'If you haven't figured it out, you're a moron.' Some of the guys he skated with, before he got into OCAD – the Ontario College of Art and Design – he had kind of conned them into 'art photos,' which were fairly heavily laden with bondage. And then, after he took those photos of these guys, he made a point of telling them he was gay. That didn't go over so well. Will didn't have a wide collection of friends, and he burned bridges with most of those people. Of course, Will was like, 'Well, if they fucking cared about me, it wouldn't be an issue.' And I'm like, 'Dude, that's always an issue. It's called exploitation.' Although a few of them, amazingly enough, not only stood up for him, but stood by him for years.

Ewan Exall: The broad historic context is that the punk and hardcore scenes had kind of collapsed in Toronto. There was a bar-punk scene full of much older people that was kinda stuck in the past; there were big corporate-style shows that occasionally featured bands I was into but lacked the vibe and spirit I'd experienced in the late eighties when I first started hanging out; and there were small shows at places like Rudy's or the Niagara Café, or, occasionally, basements and warehouses. Those shows were really fun and intimate – by small, I mean fifteen to 100 people. So if you saw someone who went to those shows and looked clued-in, you'd probably say hi to them on the street if you happened to bump into each other, which is how I met and started talking to Will. It was the spring of 1992 on Queen Street West. It was one of those classic teenage punk-rock friendships – it kinda came out of nowhere and redefined us both. My first impression of him was just kind of being blown away that there was actually one more person in the world our age who was into the same shit that me and my friends were. And that he was funny and cute.

Saira McLaren (artist, friend, former punk): We met about six months before art school, at the tail end of high school, which was almost the worst time in my life. Meeting Will was a revelation, since at the time, the thought of meeting *anyone* I liked or could relate to seemed next to impossible. I was an outsider in high school – punk rock and not really an art kid; the art kids who were nineties

'alternative' kids were *the worst*! Meeting Will was as if River Phoenix never died and went to random suburban west Toronto church basements for hardcore shows. I remember the hardcore scene being so weird: shows were in empty or rented cheap spaces, in odd, out-of-the-way locations, but not in a rave kind of way. These shows were during the day and we all went out to get a sugar high from hot chocolate and gummy worms afterward. Will was a terribly cute hardcore kid at the time – he kinda looked like he always looked, like a cross between Duckie from *Pretty in Pink* and Ian MacKaye.

Dave Munro: Will didn't do well in school. He wasn't horrible, but high school, a lot of it just didn't stick. So, theoretically, moving toward the artistic side of it made more logistical sense. At the time, it wasn't OCAD, it was OCA. You didn't require your English credits as much as you do now. And a lot of Will's written work was just incoherent. I wrote a fair number of his projects. He would just slide them under the door in the middle of the night and knew that I would do it. I wrote a whole thing on the Guerrilla Girls for him.

Margaret Munro: We didn't know he was having any difficulty at school. And I think he also didn't think he had to really put out for OCAD. The first time he tried to get in, he hadn't done much work. He just figured it was a joke. He didn't get accepted and he was like, 'Well, that's crummy.' Then the next year, he worked like crazy to get in and have his portfolio together. But up to that point, it was like, 'Do I really have to do something here?' I was glad when I realized later on that we hadn't said, 'You have to go to school!' It was, 'No, if that's what your desire is, that's fine.' It worked out.

Dave Munro: Neither of us really took art in school. He stayed in art class, but they were functionally useless: 'Today we're working with clay!' There was this roster of classes you're supposed to take in your first year at OCAD. And he's like, 'I don't know how to fucking draw people,' so he took some night drawing classes.

We picked him up after the class, and we're like, 'You look pissed.' And he's like, 'Goddamn, fuck … I've been drawing vagina all night long.' He just kept moving to try to draw her back, and the model kept rotating on the table, and had figured out what was going on and kept opening her legs. He was dying. And I'm like, 'What the fuck is wrong with you? You came out of something like that, you silly bastard.' For a lot of people, defining your sexuality requires a kind of rejection. He didn't consciously mean it, but he was revolted. He was upset. He was seventeen or eighteen. Having access to guys was almost non-existent. In the queer punk side of the world, it was pretty bad.

Benjamin Boles (art-school classmate, first real boyfriend, musician, writer): I remember Will talking about a gang of lesbians at his high school, who intimidated other people. And he had a few close friends from there when he was older. They were the ones who gave off that sort of protective vibe, and it wasn't until later on that I understood that. I think he wanted to be downtown as soon as he could. He knew he wasn't going to find what he needed out there. It's not like he was a guy who looked down on the suburbs. He knew where he came from.

Dave Munro: He was probably seventeen when we moved to Toronto. That was the leaving of our childhood house. We moved into 101 Yarmouth in the summer of '94 and lived there for two years. It was a fully detached house, with a big space in the backyard and horrible wine grapes we kept trying to eat no matter how sour they were. We sort of soundproofed the basement. We had shows there regularly. A lot of the bands that were coming through were just too small to have in a club. We could pack sixty people into the house, which also meant we were perpetually stuck with bands staying at our place.

Rori Caffrey: The first time I crashed at Will's house was when he lived on Yarmouth. His room was on the second floor at the back, and it was small and clean. He didn't own a lot of stuff. He had the same things any other punk kid had, like records and zines.

But I remember being surprised that he had a pair of creepers and a black sweater with a huge skull embroidered on it. At the time, it was really unusual for a punk kid to have stuff like this. A few years later, goth and skulls were all over the place, but at the time it was just not done – except by Will.

> *In the middle of Kensington Market, the smelly and eclectic refuge from sanitized Toronto, Who's Emma is open for anti-business. For the last year, our group of 30–50 people have run a small non-profit store without the benefit of a boss. We sell T-shirts, CDs, records, tapes, zines, studded wristbands and other aggressories, G.G. Allin dolls, vegan cookies, Snapple, patches ('Live to Squeegee – Squeegee to Live'), buttons, books, postcards and much more. We're your punk rock merchandise source, friend.*
> — Jim Munroe, *Punk Planet* #19, July/Aug. 1997

Dave Munro: I guess in the second year of that house, Irina Ceric – who teaches law at York University's Osgoode Hall now – and a group of people started working to have a space for shows, art exhibits, fanzines, community outreach: the kind of early-nineties punk rockery you'd expect. Most of the people in my house were involved in it (and some were also working with Food Not Bombs). Anyhow, Irina had stumbled across Alan O'Connor, and I still don't entirely know where, 'cause he's an odd motherfucker. Alan was living at this other house, a fairly communal house. He was originally from Ireland. The accent was long gone. He'd been teaching in Peterborough for years – he was a cultural studies professor.

Mark Connery (artist, punk, activist): I met Will in the summer of 1996 when I moved to 70 Baldwin Street. It had been a frat house and was a bit rundown, but it was also detached, so bands could play or jam there and not drive the neighbours crazy. Will's brother, Dave, had lived there for a while, and his former roommate, Alan O'Connor, lived in the house. A number of people from the straight-edge vegan hardcore scene lived there, along with a few

other folks. I guess 70 Baldwin was the Who's Emma house – at least for a couple of years. Pretty much everyone who lived there was involved with Who's Emma or hung around a bit.

Dave Munro: Unlike the rest of us, Alan actually had an income. We were a mixture of students and activists and professional idiots, and no one really had any money. As the meetings were happening, we were trying to find a space. One of the cheapest areas at the time would've been down around Queen and Dovercourt, where that kung-fu studio or karate dojo was. They offered to rent us the space beside that dojo for $400 a month, and at the time, we were like, 'How are we going to come up with $400?' Alan proposed that he'd just pay for it, which was immediately met with, 'Whoa, hey, hold on.' He was very frustrated that the group couldn't agree on anything.

During that process, we lost a roommate and Alan moved in. It became an issue almost immediately, because Alan wasn't comfortable with having a young cute gay guy in the house: he was concerned that if any other gay guys came into the house, they'd be more interested in the young guy than the old guy – i.e., Alan. He had a lot of issues. In the end, Alan basically said fuck the group and opened Who's Emma. If people wanted to be involved in it, they could. Which then became tactically tricky, because the way he saw it was that he was the philanthropic owner.

Amber Ternus: The original space, on Nassau Street in Kensington Market, was quite small, and then, because the collective was growing – it was an anarchist, volunteer collective–run shop – we moved to a location just across the street, which had a storefront. It was 300 or 400 square feet, and underneath was a basement we converted to a show space. Will was one of the main promoters of bringing live music into the venue, along with other people in the collective who were musicians. I think his brother was a musician then, too. A whole bunch of other guys – mostly guys, and a lot of them out of the straight-edge scene – were involved, and they all wanted a live-music venue where we could put on all-ages shows, so that was a big part of it. At first, Who's

Emma was a traditional punk scene/record-store space; not necessarily as politically oriented, more music-oriented. It started to change as more people from the political community got involved with it. At the time, starting in mid-'96, we began organizing for a giant anarchist conference in Toronto called Active Resistance, which happened in the summer of '98 and drew about 1,500 people. As I got more involved with Who's Emma, Will and I started becoming good friends. He and Lorraine Hewitt and Mark Connery and I, we were sort of the alternative people inside that world, and we formed a bit of a group.

Lorraine Hewitt (sex educator, punk, former Vazaleen go-go dancer, friend): I recall Will as this really skinny, pale kid who had red hair. He was really, really into music, into putting on shows there or helping folks put on shows there, and into doing art. It was a pretty unique space. It was really dirty and crazy and awesome.

Rori Caffrey: Will was an amazing cook. He put everyone else to shame. Once while visiting Toronto I was walking toward Will's house with my friend John Sharron, from the bands Union of Uranus/Chokehold/Brutal Knights. John said, 'If we ask really nicely, maybe we can get Will to make us vegan ribs.' This was long before you could find fake meats in every grocery store. Vegan ribs seemed like magic to me. We did ask, and Will did make them. He mixed two kinds of flour to make a huge ball of dough, then poured water on it and pounded it for half an hour until it looked like a wad of chicken fat the size of a volleyball. He tore pieces off, shaped them like ribs and baked them. Then he made a huge pot of barbecue sauce out of canned tomatoes, brown sugar, garlic and a few other things, and smothered the ribs with the sauce. They were so good it was unreal. When Will beat the huge ball of gluten, he would always take off his shirt. Now, most people probably imagined Will to be a scrawny little waif. Not so – he was ripped! He had the upper body of an Olympic swimmer. He had probably never played a sport or set foot in a gym, so I'm not sure how he got it.

Mark Connery: A number of the straight-edge vegans were pretty macho, even if they expressed liberal sympathies, but Will was respected enough that they were all pretty clued into homophobia not being cool. Sometime in '96 or '97 there was a band crashing at 70 Baldwin and the dudes from the band were talking about whether it'd be worse to be fucked in the ass or have your throat cut. They pretty much agreed that ass-fucking was worse. I wanted them gone, and a couple of the straight-edge guys told them to split. That was very cool, and I think it was Will's influence that made that happen.

Rori Caffrey: Will was out when I met him. Not to his parents, but to everyone else. He was not only accepted by people in the scene, but loved by them. I don't recall any tension around his sexuality. Blatant homophobia was abhorred in the scene and I'm positive that if anyone had been disparaging toward Will, they would've been blackballed, if not beaten up. I hate to think what Dave would've done to them. That said, years later, a bunch of us were reminiscing about the punk days and I mentioned the awesome feasts Will prepared at the house on Yarmouth. Will said something to the effect of 'Yeah, I made all that food and everyone else ate it. I was just the little gay kid expected to cook for everyone else.' Maybe Will was just being crabby, which wouldn't have been out of character, but that was hard to hear. Like I said, blatant homophobia was not tolerated, and lots of us walked in the Pride march and partied at gay dance clubs, but it was also a very straight and heterocentric scene. He'd never mentioned it to me, but he must have gotten bad vibes off some people that left him with these feelings.

Saira McLaren: I remember it was a time of sexual discovery, becoming interested in dating; I think for both of us, dating was synonymous with unrequited crushes. I'd ask boys Will had a crush on to hang out, and then I'd leave them alone with Will soon after they showed up. It was weird and misguided matchmaking on my part, a kind of bait and switch.

Dave Munro: That was roughly the time period that Will came out of the closet to my folks. He would've been maybe eighteen, and we were living on Yarmouth. Will had missed Mother's Day, and my mom's big on at least calling. I'm horrible at those things, and Will was even worse. We were riding our bikes back to the house, and he's like, 'I'm going to talk to Mom tomorrow, and go out and have dinner with her for Mother's Day. I'm going to give her a gift.' I said, 'What's that?' And he's like, 'I'm going to tell her I'm gay.' I said, 'You're a fucking idiot.' And he's like, 'Don't be an asshole! Sometimes you're really fucking hard on our mom. You don't understand how progressive she is and all that she's done!'

Margaret Munro: Will came home – I don't know if it was Mother's Day or not – and he was like Velcroing to me. I remember being in the bathroom of our bedroom and he was on the bed and he said, 'I have a partner.' And I said, 'Male or female?' And he said, 'Male.' It was like he was watching my face. I was surprised at my own reaction. It makes you wonder if I did know, but I didn't. It wasn't foremost in my mind.

Dave Munro: Though my mom would ask if Will liked girls, she wasn't really willing to address it. There wasn't a guy around that he was dating. That would have been a very different scenario. But he was obviously not dating girls. Anyhow, they were out for lunch, and Will said, 'Mom, I got something for you.' And she's like, 'What's that?' And he said, 'I'm gay!' And my mom started to cry. My mom's fantastic at crying – there's blubbering and shaking. As opposed to waiting for words, Will blew up. 'Fuck you!' Flipped the table, food everywhere in the middle of the restaurant. Left her and stormed out, came home and broke all our dishes. He's telling me the story, and I'm nearly peeing myself laughing. He's so fucking mad. My mom phones up and is like, 'Is Will there? Can I talk to him?' I'm like, 'I don't think so.' She said, 'I may have not handled something well today. He told me something very special and I don't think he understood my reaction. He was very mad. You have to understand – I felt so bad that I spent my entire life pushing him into being

something that he's not.' Which was not what Will thought her reaction was on any level.

Margaret Munro: He said, 'I expected you to react the way you did.' And he got pissed at me anyway. My face tells the story.

Dave Munro: He had asked my mother not to tell Dad, because my dad had made numerous idiotic homophobic comments throughout our lives. Not that he was picking on people for being gay; it was just the Andrew Dice Clay version of dealing with things: 'I grew up in a dumb time period, and I'm handling things like an asshole.' It was enough that Will was like, 'Yeah, I'm not discussing it with that guy.' So my mom said, 'All right, I won't tell him.'

Margaret Munro: It was all good, and then he said, 'I don't want Daddy to know.' And I said, 'Well, fine.' But we were United Church people, and this happened to be at the time when the vote [on whether legislation for equal government protection to lesbian and gay individuals should be amended to exclude sexual behaviour] was going on, and there was all kinds of kerfuffle and people were getting upset. I was getting lambasted right, left and centre. So I said to him, 'Look, Will. I can't carry this. I'm telling Dad.'

Dave Munro: At six in the morning, there was banging on the front door. I walk over and open it and there's my dad. He's not blinking. He's wide-eyed. He's like, 'Where's Will?' I don't know how this is going to go down. Part of me is looking for a bat, just in case. I go upstairs and say, 'Hey, Will, Dad's here.' And he's like, 'What do you mean, Dad's here? What time is it?' I followed Will down the stairs a bit and kept myself on the other side of the wall. But my dad just grabbed him and hugged him and said, 'Come here, son, I love you. I'll always love you. We'll always love you. Don't ever think otherwise.' It was a very wonderful moment.

Margaret Munro: 'You're our son. I don't care what you are. You're our son, and it's as simple as that.' We accepted it from then on. I

was really concerned that – now it's a joke, but I was worried I would lose my son to AIDS or whatever else. That was when AIDS still felt like a death sentence.

Saira McLaren: When I slept over at Will's house, I would stay in his bed. I remember one time, his mother came over early and walked into the room, and let out the loudest scream: 'I thought you were gay!'

Joanne Huffa: Some of the most fun times at Who's Emma were when we'd have dance parties either in the store or out front of it. One really fun night, Will, Lorraine Hewitt and I (and others, I'm sure) played a bunch of fun records, mostly eighties stuff. The room was tiny and it got super hot and sweaty with everyone dancing. I played Joan Jett's 'Bad Reputation' and people went nuts. During that time, Will dated Ben Boles and they were, like, the dreamiest couple in the world.

Benjamin Boles: I met Will in 1996 at OCAD. I'd been drinking all afternoon with other first-year kids and one of the kids was struggling with his sexuality and we all knew he was gay, but he was waffling. The gay OCAD club – I think it was called Pink Out – was having a meeting, so we went over there. Will was in charge of Pink Out, of course. It'd been dormant for a while but he decided that OCAD needed a gay club again.

Dave Munro: When Will was first at OCAD, he found out there used to be a queer club. He decided to start it up again. I was like, 'That's awesome,' not knowing that it was a paid position. So he started this thing up a) because he was getting money for it, and b) 'I can fucking meet some dudes. They show up, we're having pop and chips and watching gay porn.'

Benjamin Boles: If I remember correctly, they were showing some film. It must have been a Bruce LaBruce film. It was somewhere within that Fifth Column/classic queer-punk world. This was great, because I had limited interaction with the straight-edge

punk scene, but the more crusty drunk-punk scene had been how I'd spent my teenage years. While the queer subtext there was and is still relatively submerged, it was still part of the package. It was the first time I'd met somebody who was really aware of that hidden subculture of punk, and who was really interested in it. We exchanged numbers. At that point, he was living near Christie and Bloor with his brother. And above Will's door, there was a pair of underwear with 'Gaylord' stitched in it.

Dave Munro: When we were living at Yarmouth, it was the first time he actually used the underwear imagery. He had written a zine called *Transgression*, which was really good. On the outside of the actual zine, he had a connect-the-dots picture of a pair of Y-fronts. He was hoping to get a bunch of other people to contribute, but it just kind of got tucked away and disappeared. When that house was breaking up, Will moved into the studio down at Liberty and Fraser. Max and Nick McCabe-Lokos of the Deadly Snakes eventually moved down there. I moved down there for a couple of years as well.

Max McCabe-Lokos (musician, actor, artist, friend): I moved into a warehouse at 47 Fraser with my brother, and Will lived down the hall in a smaller one. He was very parsimonious – he even shared a phone line with another tenant down the hall. The neighbourhood was cool, but empty. One store, one restaurant. Lots of free parking. Just down the street was 9 Hanna, which also had a bunch of people living in it, but there was nothing between the two buildings, just a wasteland.

Rori Caffrey: Liberty Village in the early nineties was nothing like it is now. When I visited Will at his loft back then, it was the farthest west in Toronto I'd ever been and the neighbourhood was like nothing I'd ever seen, anywhere. It was like something out of a dystopian sci-fi movie in which culture had been outlawed, so all the artists, musicians, writers and fashion designers hid away in these derelict buildings at the edge of the city. There were no stores, restaurants, parks, no greenery of any kind. Just

these beautiful old factories. Cars rarely drove through the area and you hardly ever saw another pedestrian.

Benjamin Boles: From what I understand, I was his first real boyfriend. He might have kissed somebody before that. I'd had a short-lasting boyfriend before him, but he was so identified – I mean, 'Gaylord' above his door, leader of Pink Out. He was going to claim that space. Our first 'date' was when he asked me to come over to see some gay punk movies. It might have been Bruce LaBruce's *No Skin Off My Ass*. We also watched *Salò*, the Pasolini version of *120 Days of Sodom*. Very bad date movie.

Dave Munro: Benjamin Boles would be his first very substantial boyfriend. That was a disaster. I think it was frustrating because Ben was so ambivalent about the relationship.

Benjamin Boles: We dated for about six months, but there was a crossover period because I also started dating the female backup singer in my band. At first that seemed okay, but then it became clear that it wasn't really that okay.

Alex McClelland: Will wasn't really forthcoming with boys. He wouldn't actually say, 'I like you.' In 1997, Will had had his first big art show, a collaboration with Chandra Bulucon where they both showed their work. His original idea had to do with him stealing underwear from this hot hardcore boy he really liked and dreaming about him all the time because of the underwear, and that's why he started making work about it.

Benjamin Boles: Before I'd met him, he'd already gotten into the underwear as a medium. I know a lot of it was about, or seemed to be about, confronting people with their discomfort around youth queer sexuality. There's this 'stranger-danger' feel built around how adults look at that.

Luis Jacob (artist, friend, sometime collaborator): The first time I met Will, he was having a show at the Nora Vaughan Gallery around

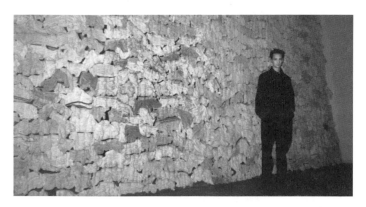

King and Spadina. I remember walking in, and seeing this giant curtain – it actually felt like a wall – of underwear. It was all these white undies sewn together, and it made this big architectural intervention in the gallery.

Margaret Munro: That was the time when Michael Coren was being interviewed on CBC Radio, asking whether this was art – could underwear be art? There was all the controversy. We were terrified something was going to happen to Will. The interviewer tried to get a hold of him, which is another story, and Will was busy and didn't bother to speak to him, I guess – so he assumed Will was a pervert. That was the way it was being reported. It wasn't really recognizing it was a kid who was doing this art. It was just really scary, that opening night.

Ian Munro: That's why we went down there. That's why a lot of people were there. We expected people there with pitchforks and flames. But the bastard ended up launching William's career!

Luis Jacob: I thought that show was really interesting because there was a nice sense of, like, hiding and showing at the same time. Like, underwear is *underwear*, right? You're not supposed to see it, but you're supposed to have it. To put it in an exhibition on such a massive scale is to show something that's usually kept from view. As well, the wall created a kind of privacy, like a space

inside the gallery. It wasn't exactly private, but it had a sense of enclosure as well as exposure. And that was also indicated with the invite. Will and Chandra made this beautiful little cardboard invite – a little piece of cardboard with a little cloth from underwear sewn around it, and then this little metal peephole stuck into the paper. For me, that encapsulated so much of what I felt about seeing the show – it's not exposing everything; it also suggests there's something more covert. You can see so much of his personality and his ideas as an artist coming through in that exhibition.

Alex McClelland: I first saw Will at an art event, and I was like, 'Holy shit, that guy is the hottest guy ever,' and I was shy and overwhelmed by him, because he just had this cool, calm confidence about him. He was always wearing his bike courier bag, because he was obsessed with biking. I thought that was really hot too. In 1998, in my second year at OCAD, I helped a friend make some flyers for her DJ night. We bought all the 45 records at the Goodwill and photocopied all these circles with the name of the event on them and glued them to the record, and handed those flyers out at school. Will wound up getting one. He thought the flyer was cool and was so excited by it that he came to the event and talked to me and asked my friend for my phone number, then called me and asked me out on a date the next day. We went on another date the next week, and I visited his studio on Fraser Street. We rode our bikes through the building at 9 Hanna Street and went for a walk close to the highway. This was a big date for me. I hadn't really gone on dates with people since I'd found out that I had HIV. But I'd decided, 'I'm going to tell him this time.' We climbed to the top of the Kentucky Fried Chicken sign, and you could see the whole city and it was dark out and really beautiful. I kind of blurted it out, and he was really supportive and sweet and we hugged and made out a bunch up there. I was relieved.

After that, we just started hanging out a lot. Around that time, he was starting to work on his second show, his anarchist underwear show, which was happening at Who's Emma. That's

the one where he made all the Molotov cocktails with underwear in them, and the anarchist flag and a bunch of other stuff. I helped him out with organizing that show. It was one of the first times I met a lot of his friends, and I was super, super shy because I was nineteen or something, and he knew everybody.

Bennett JP (punk, filmmaker, friend): The Super-8 short *Rebels Rule* was shot sometime around 1998 or 1999. It was conceived by Will and shot by Scott Treleaven and Saira McLaren. The film depicts some kind of anarcho-queer bootcamp on the rubble of a factory, with self-defence training and Molotov-throwing practice, but it was also an allusion to the actual youth anarcho scene that was flourishing at the time and the strong queer element involved. Will was already seeing Alex, but he wanted me to be in the film and probably figured I wouldn't feel comfortable kissing a different boy, so he paired us up. The film is like an anarcho-queer recruitment film, with Will as the ringleader. Originally it was supposed to be accompanied by an audio track of anarcho-type kids talking about how being queer related to their activism. The circle-A flags were made out of underwear, of course. The film somehow got 'lost' in an apartment in N.Y.C., so it wasn't officially screened, but the flags were exhibited at Who's Emma along with underwear Molotovs and underwear covered in crusty band patches that I had silkscreened, mixed in with some other patches he had. In return for the patches, Will made me a circle-A patch out of Ninja Turtle underwear, which I still have.

Benjamin Boles: Will was one of those kids like Jubal Brown who was already gaining notoriety while he was still a student. The work back then seemed more overtly about his own personal history. Not too long after that, it became more about the larger history of people like him, like he was trying to get in touch with the culture that came before.

John Caffery: Around 1998 or so, I lived at Sullivan House, which was this house full of activists, artists and students near Grange Park. I was nineteen and had just moved to Toronto from Hamil-

ton. It was this four-bedroom house that twelve people lived in. They ran Food Not Bombs out of there, or a lot of the meal preparation. It was always a bustling place. Not too long after I arrived, folks started saying, 'Oh, we've got to introduce you to Will.' Initially, it was kind of like they wanted to set me up, like a romantic kind of date situation. I was a new gay to the city, and a lot of the folks were more on the hetero tip, and I think sometimes when people know two queers, they're like, 'Oh, you need to be in a relationship together.' Will came by the house one day, and we hit it off immediately. I quickly fell in love with him, although it was a platonic love. We didn't have that type of chemistry, but we ended up hanging out a lot. He was super friendly and easy-going, but clearly had this wealth of knowledge and an amazing level of references I could just sponge up.

Bruce LaBruce (artist, filmmaker, pornographer, queer icon): That was the thing about him. He really had a calling to share the stuff he was so passionate about, and to educate people – not in a pedantic way, but to get people infected with the same spirit and be excited about what he was excited about. So he had a very infectious personality and effect on people.

Alex McClelland: Will and I started volunteering at the LGBT Youthline around 1999. It was in the basement of the Shout Clinic on Jarvis Street; it was supposed to always be in a secret location and had only been around for a little while. Before the Youthline, Will had done TEACH – Teens Educating and Confronting Homophobia – where you go into schools and do anti-homophobia workshops. He was always very much engaged in this kind of work.

Benjamin Boles: It wasn't until recently that I started to get a better idea of why Will was so motivated to do all the things he was doing. He wanted the world to be a better place than what he'd experienced in high school, even though he was aware that what he experienced was better than what his predecessors had experienced.

Alex McClelland: Will and I did volunteer shifts together for about three years. It was a fascinating and rewarding experience, and people would call with everything: sex questions, support, parents calling about their kids, weirdos calling while jerking off and people who just wanted to chat with people. There was a list of regular callers we'd contribute to – some had real concerns, and others were scammers and had some kind of sex fetish thing. Will was fascinated by those folks and always loved getting their calls – it was something wacky to talk about and he always loved freaks. Will was eventually given more responsibility and took on the staff position as shift supervisor. Around then, he was working as a cook at the Midtown on College Street, so doing something to support the queer community was important to him. He was really into the Youthline 'cause when he was younger and living in Mississauga he had no real support.

Joanne Huffa: One of my most vivid memories of Will at that time, and it's something that jumps into my mind frequently, especially now that I'm in my forties, happened pretty early in Who's Emma history. Along with some others, Will decided to form a youth group for the punk LGBT community, aged eighteen to twenty-five. He was working at the LGBTQ support line and thought it would be good to have something that was welcoming to queer punk kids. He asked me if I wanted to be part of it, and I said, 'But I'm twenty-six. Aren't I too old?' With a look on his face that I can only describe as gleeful, he put his hand on my shoulder and said, 'Joanne, you'll never be too old for anything.'

> *When I started making art, I was a very suburban person. I very much needed to meet other queer people, I needed to have a sex life. Being a suburban queer kid, as anyone who's grown up in that environment would understand, it's one of the most isolating things you could go through. An organization like the Youthline was a way I could reach out and network with other people. I had to do it for my own peace of mind and for the teenage years I didn't get.*
> — Will Munro, *NOW Magazine*, June 26, 2003

Alex McClelland: I was immediately totally crazy about Will, and I think that was a bit intense for him, because he was a brooding, tortured boy who thought love was always unrequited. He was a bit overwhelmed that I was straight up with my emotions. He was always hanging out with these straight guys who were hard-core punks, and he'd be in love with them. That was the situation with Bennett JP.

Bennett JP: I was open with Will about being straight, but either he didn't believe it or didn't want to. He was eventually able to seduce me, though. He had some great tapes and records – Neurosis followed by T. Rex, I believe, was the winning combination. I was aware that this was a seduction in progress, because he told me about how the boy he'd been dating previously, Benjamin Boles, had made a video in which he seduced the camera while T. Rex plays in the background. I agreed that T. Rex was indeed sexy music. We sat on his couch in silence for a while before he kissed me, which took a lot of courage. I cared about him a lot and I felt very comfortable with him, so I went with it. This was the start of a brief period of time where we did have a sexual relationship. I loved him deeply but I just wanted him to be my best friend and he wanted me to be his boyfriend, so it was difficult to try and re-establish boundaries and such, but eventually we were okay. If I was gay I would've held on to him and never let go, but ultimately I had to draw a line. When Will found Alex, I was very happy for them. Alex was like me in a lot of ways, except he was totally gay and seemed to identify as an artist himself, so he was perfect for Will. It didn't really stop Will trying to get me naked in the name of his artistic pursuits, but that was all out in the open and Alex was often involved, so it was cool. We would all play dress-up and take photos and stuff and it was very chill.

John Caffery: In those first couple years that I knew him, we did drag together. Lorraine Hewitt invited us over to her house, and she dressed up Alex McClelland, Bennett JP, Will and myself. It was my first time ever doing drag, and it felt wild.

Drag virgins John (from left), Bennett JP, Alex and Will
during their first outing as queens

Lorraine Hewitt: **Oh my god, I could never forget that. They went on to do drag many, many times in the following years. They loved it, and had far more professional makeup jobs done in the future than what I did to them. I was, like, the femme friend who had a lot of makeup at my house, and I'd been into wigs and all that. They came over super excited, and we all played for two hours, putting makeup on all of them. I can't remember what Alex and Will were wearing, but I'd lent John Caffery this long negligee, a sort of long slip-dress. Those guys had such a ball getting all dragged out. We were all so young still. I was maybe eighteen, Alex was close to my age, John was about a year older and Will was probably around the same age as John. We were doing so many things for the first time. They all became much better at drag after that. I can't say it was the best they ever looked, but they looked pretty good.**

Alex McClelland: That must have been around the first time I met John. And it was the first time all of us had done drag – maybe not me – but the first time they had all done drag. It was hilarious. We drove down to the CNE and posed in front of buildings and stuff.

Bennett JP: One time Will and Alex took me to a bathhouse on Yonge Street, which was definitely a new experience. We didn't go for any hanky-panky; it was purely a cultural field trip. Will

felt it was important to experience various realities of queer experience. They gave us towels and a key for a room. We got undressed in the room and put the towels around our waists, then walked through the narrow halls as various Paul Bellinis passed and looked us up and down. I remember the godawful fluorescent lighting above and rooms that were bare except for some kind of creepy sex swing or something hanging. It was a very unsexy experience for me.

John Caffery: Part of the fun of hanging out with Will was that it was more creative, and it wasn't about drugs and alcohol. With a lot of people, it's like, 'Let's get together for a beer,' or 'Let's go get drunk.' That was never the priority for Will. It was always something else that was the agenda. And that also flipped a switch for me, like, 'Oh, there's different ways to get together.' Coming from Hamilton, that was not my experience.

Lorraine Hewitt: Will was always a straight-edge vegan, but he was unlike a lot of the other straight-edge vegans that were around at the time. First of all, he remained so. All the time I knew him, he never went through a phase of debauchery and doing all the drinking and drugs. And also he never gave anybody a hard time about it. Even though those were very highly held principles for him, he was very cool about not making it a self-righteous thing.

Amber Ternus: Alex and I used to tease him that he was only straight-edge because he was so cheap and he didn't want to spend money on booze. Most of the time, he expressed it as a health thing. And he was highly ambitious and very organized, and so cheap. He saved everything, he would eat at work, he would buy cheap groceries, he'd go to shows but never spend money on anything – he wouldn't even buy pop. He was part of the scene, but he was a very financially conscious guy.

Rori Caffrey: One of Will's quirks was how fucking cheap he was. He wasn't a beggar and he wasn't poor. He just wouldn't spend money unless he absolutely had to. He once told me he liked to

play a game where he counted how many days he could go without opening his wallet, and his 'high score' was something like twenty-five days. If we ever planned to meet for coffee, he would always show up and just order water, then suggest going to do something else, which, inevitably, was something free. But that was one of the best things about Will. He'd never settle for doing anything as boring as going to a bar for drinks or seeing a movie. I once came to Toronto and Will suggested we check out some art together. I figured galleries. Will wanted to check out graffiti. Of course, he was too cheap to take the TTC, so he doubled me on his bike.

Amber Ternus: Most of the time I knew him, he made his living in kitchens. He made a little bit of money here and there from some of the shows, but he put a lot of that money back into the events, so he wasn't taking a really big paycheque from any of them. Just working in kitchens, saving his pennies, saving up to buy a bar. I'm sure he probably had $30,000 or $40,000 in the bank when he was in his twenties, because he saved everything.

Alex McClelland: His second solo show, after the anarchist one at Who's Emma, was his Boys Do First Aid show at the Overflo Gallery, in 2000. My mother has a cottage near Peterborough, and Will used to love going there. Near that cabin was this weird evangelical Christian missionary place where you could go and they'd give you sandwiches on white bread and tea and lemonade and talk to you about God. Outside, there was a giant billboard painted with a sunset and then in front of it were all these 1950s mannequins re-enacting the crucifixion – intense, life-sized and really weird. Will fell in love with a lot of the mannequins and convinced me once in the middle of the night that we should go steal a bunch of them. We stole two of these cute young boy mannequins, and they ended up being in a number of Will's shows. These mannequins were ever-present; Will was obsessed with them and made underwear for them, and they were a centre-piece of Boys Do First Aid. It was all stuff he made out of under-wear, but he replicated these 1950s first-aid images, like people compressing wounds. He also made a stretcher out of underwear

and a whole bunch of condom packages with first-aid symbols on them and a couple other things like splints and bandages and mannequin parts that were bandaged up. The show went really well and he sold a bunch of the pieces.

Bruce LaBruce: I was at that opening. I always loved how he played with that dangerous area of representation with boys and Boy Scouts and the gay connection, NAMBLA, all that stuff. In a way, Will and I had a similar approach because we both presented radical or controversial subject material that was considered politically incorrect, in a romantic, almost spiritual, way.

Alex McClelland: Mitchel Raphael from the National Post interviewed him about that show and his work. It had a picture of him standing in a studio with his hair sticking up and there's a clothesline with some underwear hanging on it. And in that article, he said that his Boys Do First Aid art show was – the way Mitchel wrote it – inspired because his boyfriend had HIV. I hadn't told anybody except for my parents, and then it ended up in the National Post that Will Munro's boyfriend had HIV and that had inspired his art. He hadn't previously told me that any of his art was inspired by my experience. I was angry and refused to talk to him for a couple days. Apparently, Will had said that in passing to Mitchel, and had asked him not to print it, but Mitchel had printed it anyway. Will was really sorry. He said he hadn't cried in ten years, but that moment had made him cry. Everything was fine in the end, but it was an intense revelation for me. It was obvious that his art was about that, but I'd never thought it through.

Dave Munro: Alex was a big point in Will learning to care for other people. Because of Alex and his health, Will was perpetually like, 'He's staying up the same hours as me. And he's riding in the rain! What if he gets the flu?' It was a lot for Will to ever acknowledge that he cared for Alex. That being said, he never told Alex that he loved him.

Alex McClelland: He was horrible at talking about his feelings. He told me a couple times that I was one of the few people he really loved, was in love with. But he would never say to me, 'I love you.' Never, the entire time we were together. He was horrible at expressing his emotions. He'd find other ways, through actions and stuff.

Amber Ternus: You never felt couple-y around Will and Alex. To me, they were just my two best friends, and that was it. You never felt like you were a third wheel. It was important for the community to see that you could be in a monogamous relationship – or mostly monogamous relationship. It had a big impact on everybody.

John Caffery: I remember our friends Amber and Paul – they were both queer-identified, but they had this great platonic love and they decided to have a punk-rock wedding down by King and Dufferin. In the late nineties, there wasn't much down there – it was all empty lots. We went down and held this ridiculous ceremony.

Amber Ternus: I was like, 'I don't want to have to get married to some guy to have a wedding. What a rip-off.' To our friends, Paul and I were already a platonic husband and wife, the ultimate couple except we didn't hook up. Anyway, this joke extended to the point where we decided we wanted to have a punk-rock wedding. We just picked a day. Will made a bunch of knitted flags. I had a wedding outfit: a tiny lace miniskirt and lace pants and boots, and short punk-rock hair. Paul put on a suit. We told people to bring anything that could make music. We didn't have any battery-operated stuff. It was all live. Probably fifty or sixty people came. We put up flags all over the parking lot, like punk-rock banners with queer symbols, radical symbols on them, and streamers, and made a stage. Everybody performed and then our friend did this fake wedding ceremony. It was a really good day.

John Caffery: It was nonsense and celebratory and also kind of political. Things like that were pretty commonplace around Will.

Luis Jacob: Will and I, in our own different ways, drew a lot of inspiration from queer culture, artist-run culture and music culture, to develop the same ideas about community. For Will, it seemed like there was such an urgency, you know? Which was so inspiring. For him, it wasn't a theoretical issue, like, how does community happen? It was a need.

Rock show / You came to see a rock show
A big gigantic cock show
You came to see it all
Rock show / You came to hear it
You came to sneer it
You came to do it all.

— 'Rock Show,' Peaches

If you wanted to see cock in Toronto some evening in the mid-2000s, you had a few choices. You could visit a bathhouse, tucked neatly away between brick buildings in the gay enclave at Church and Wellesley, and meander through steam and sweat, past men in towels, to a room, or a corner, or a corridor. You could troll the filthy aisles of the Metro porn theatre near Bloor and Christie, shuffling with careful nonchalance over the sticky, stained carpet in the watery light cast by the grainy supersized studs grunting and moaning onscreen. You could try your luck after dark in the thickets and brush of a downtown park – Allan Gardens, at Carlton and Sherbourne, likely had the highest proportion of cock per capita, but it was far more exposed than the lushly treed expanse across town at High Park, where you could trade hasty blowjobs in the high reeds around Grenadier Pond. Or, if it was the final Friday of the month and you were itching to find a cock-friendly safe space where you could hang out with like-minded folks, listen to music and have a drink or ten, you could go to Vazaleen.

Vazaleen began at the El Mocambo on Spadina, which was, at the time, one of the city's most deliriously seedy rock 'n' roll dives – the Stones had famously played there, and Blondie, and Hendrix; it had been the backdrop for over a dozen bracing live albums by everyone from Elvis Costello to Stevie Ray Vaughan. The walls were gummy and grimy, the bathrooms mildewed pits, the downstairs stage awkwardly accessed by wandering around an architecturally weird array of walls and corners. When you leaned up against the bar, you'd swear you were getting a contact

high from the aggregated layers of drug-infused sweat left behind by bug-eyed, clenched-jawed patrons and performers. The El Mo was an historic showcase for swivelling hips, thrusting pelvises, deep-throated microphones, thick black eyeliner, glam and guts and various effluvia, and over a century of awesome music.

Vazaleen began as Vaseline — as in, the petroleum-based, archaically homo-iconic lube — but the spelling was changed a year or so into the night's tenure to appease some litigious brandname protectors. From the start, it was an anything-goes Xanadu. If you wanted cock, it was there for the finding — or grabbing — whether in the form of blurry retro porn, projected on the walls and screens and overhangs by artist Scott Miller Berry (who would go on to oversee Toronto's Images Festival of video and multimedia art), or in dreamy Super-8 art films by Scott Treleaven, whose strange fantasias about vaguely military revolutionaries left you feeling tingly, or right in front of you, dangling from the proudly naked guy who doffed his clothes as soon as he got his hand stamped at the door. There was cock and ass all over the place, and not just for boys who dug boys. You could hold hands with a girl under a table and slowly realize she was packing under her short, tight skirt; you could ogle impressive packages on beautiful trans dudes; you could watch a straight punk-rock couple go all the way on the dance floor.

It sounds so salacious, and maybe to an outsider it was, but the minute you walked through the entrance to the club, you were overcome by an almost kindergarten-naive sense of belonging. The weird, wonderful, magical thing about Vazaleen — which was also, arguably, the weird, wonderful, magical thing about Will, who came up with the idea on the cusp of the millennium — was how it really and truly welcomed everyone, regardless of gender, class, race, size, sexual proclivity, culinary peccadillo, neighbourhood affiliation or musical taste. When you were there, you felt not just desired and desirable, but like whatever turned you on — fruit, feet, silk scarves, leather, bondage, bruising, baby talk, plain vanilla missionary action — was nothing to be embarrassed about. Imagine the thrill of entering a world without shame.

Vazaleen wasn't just about sex, even if sex was the undercurrent that made the air vibrate. It was about community and a non-judgmental kind of unerotic hedonism, and the sort of ground-floor activism that's catalyzed through rapt, breathless conversations with random acquaintances when you're jammed shoulder to shoulder in a packed club, trying to prevent your sweating beer from being upended by the bodies surging around you, and shouting to be heard above whatever's blasting through the speakers. Even once it moved from the El Mo to Lee's Palace up in the Annex, where drunken students stumbled past the crowds of regulars who'd formed a line so long it snaked down the block and past the stuccoed storefront that eventually became a Tim Hortons – or perhaps *especially* then – Vazaleen was the best fucking rock show you'd ever seen. Buoyed by an irrepressible desire to flaunt and honour his roots, Will showcased a mind-boggling array of queer and punk rock and electro icons of the past, present and future.

The lineups were consistently revelatory, even when the performances weren't stellar. Some of Vazaleen's most memorable acts over the course of a half-dozen years: Peaches, Gossip, Kembra Pfahler, Lesbians on Ecstasy, ESG, Nina Hagen, Toilet Böys, Lady Bunny, Vaginal Davis, Boy from Brazil, the Hidden Cameras, Limp Wrist, Gravy Train, the Need, Cherie Currie (of the Runaways), Jackie Beat, Kids on TV, Glass Candy, Stink Mitt, Les Georges Leningrad, Duchess Says, the Organ, Scream Club, the Butchies, the King Cobra, Tracy + the Plastics, Teenage Head, Jayne County, Har Mar Superstar, Joey Arias, the Deadly Snakes, Carole Pope. Of course, Vazaleen represented only a fraction of what Will actually did, made, put on, produced and promoted. In about a decade, the guy started up an ongoing electro party, a no wave night, an amateur strip-club extravaganza; helped manage and support the Hidden Cameras, a Toronto indie-pop band that went on to become fey international stars; sewed hundreds of pairs of underwear; stitched banners; silkscreened thousands of posters and wheat-pasted them on telephone poles around town; volunteered regularly at a support line for LGBTQ youth; travelled; laughed like a maniac; cooked – and well, too; took over and co-owned

the Beaver, a brunch-spot-turned-restaurant/bar that became a beloved hangout and key hub for queers in the city's west end; stayed up all night and rode his bicycle from one side of the city to the other more times than you can count. But Vazaleen, until it reached its tipping point and no longer felt like the all-inclusive freak show he had originally imagined, was a crystallization of so many of the values and visions Will held dear, and the worlds he brought together in a deliberate collision.

This is a sweat-soaked, heart-pounding, glorious glimpse of what it was like to be there, and how it changed the city forever.

Bruce LaBruce: I was never totally involved in the gay scene and the Church-Wellesley Village scene in Toronto. I would certainly go to hang out at gay bars. In the mid-eighties, I would get kicked out of gay bars for wearing swastika earrings in the Village. The gay scene was much more glamorous back then, because most of the bars were on Yonge Street. There was something more edgy about it. It was more like 42nd Street. It was tougher and rougher, and a bit more dangerous. Dirtier. A bit more porny. I used to go to the Quest, and the Parkside Tavern and the St. Charles Tavern. They were pretty rough-and-tumble kind of gay bars. And also, as they were back then, a place for all sorts of misfits to hang out. Criminal elements, ethnic minorities, what have you.

Lynn McNeill (Beaver owner, former Lee's Palace bar manager and booker, Toronto fixture, gay rock–scene veteran): I never ever did queer Toronto particularly. I was never Church Street by any means. I had come back here from Berlin in January 1990, and I didn't do traditional queer New York either, or traditional queer London or traditional queer Berlin. My only reference point would be Buddies in Bad Times Theatre. Jackie Bruner, who was a DJ at Lee's and the Dance Cave, started DJing a Friday night at Buddies. This was in the early nineties. That's as close to queer Toronto as I got. There was a coalescence of the whole rock 'n' roll indie thing. That was the first time I saw it here in Toronto, because Jackie played rock 'n' roll music, and it attracted a 100 percent

queer crowd – with the exception of Jackie. There was much more crossover and interesting stuff in the seventies. Then gay culture split off from subculture. I literally date it at *Saturday Night Live* – either *Saturday Night Live* in 1975, or the Clash album *Give 'Em Enough Rope*, which came three years later. The cool queers all went headfirst into punk rock and the art scene and the warehouse scene. And the traditional white gay males went headfirst into disco – not even Donna Summers, but orchestrated disco and the whole ugly gay dance music scene. Gay culture in the 1970s was an amalgamation of everything. It was Roxy Music and David Bowie and rock 'n' roll all over the place, and then disco was incorporated into those nightclubs. I can remember all the groovy kids going, trying to get these DJs to play something other than really traditional gay dance music. So we had to splinter off from that and form our own things.

Dave Munro: Roughly around when Will started going to shows in Toronto, one of the main punk venues was a place called the Apocalypse Club. It was down on College Street, and it became El Convento Rico, which had some of the elements of Vaseline before there was Vaseline – it was this obscure tranny bar in the middle of Little Italy that opened up just at the time everything else was closing. Things were still shutting down around 1:00 a.m. in Toronto, and this place would be kicking off. They weren't necessarily selling booze. You had a lot of the older Italian men in the community coming out to go dancing. They were leaving the social community clubs that are down there, and were sort of like, 'Ah, I'm gonna go dance with the pretty ladies.' No one talked about it, but that's what was happening.

Bruce LaBruce: That's what Will was always about. He wanted to establish more queer events and venues outside of the Village, and avoid some of the problems of ghettoization, and be more integrated into the larger culture and crossover with punk. But he was still connected to a gay or queer consciousness as well, and some old-school gay stuff, which is what I always connected with Will on because I always had a fondness for old-school gay consciousness

from the sixties and seventies — *The Boys in the Band*, the original post-Stonewall gay 'clones' in San Francisco's Castro.

Dave Munro: Will started talking about the idea that became Vaseline sometime around '98. He was starting to try to spend a lot of time on Church Street. Will didn't develop an appreciation for house music until it was well past the time that he should've. I'm pretty sure he lost many a gay point for that one. He was trying to go to clubs. He would go to Buddies in Bad Times. He would visit random bathhouses and would come back like, 'You should've seen the fucking weirdos.' It just wasn't his culture. It wasn't his community.

Alex McClelland: Will hated Church Street. We went to Pride together once or twice. The first time we went, it was before they put up all those barricades, so you could just join the parade. He actually held my hand through the whole thing, and I think we were carrying an anarchist flag. But he hated Pride, and he thought gay bars were stupid.

Dave Munro: Around '98, the Chicago hardcore band Los Crudos had come up to play a bunch of shows, and by that time it was fairly common knowledge that Martin Sorrondeguy, their frontman, was gay. Will would take him out at night while the rest of the band was sitting around the city, and they'd go dancing at El Convento Rico. Martin was one of the few people with whom Will could merge those worlds. And the more time that Will spent on Church Street, the more frustrated he was with it, because he didn't drink and he didn't want a relationship with people who couldn't put together a sentence because they were too messed up.

Alex McClelland: He wanted to put on something in the west end, and knew [club booker and promoter] Dan Burke through the garage-rock band the Deadly Snakes. They were kind of blowing up then and they would play at the El Mocambo all the time, and Dan Burke was the guy behind the club. Will started talking about this hypothetical night and I would brainstorm ideas with him.

We started brainstorming names for it and came up with this big list of possibilities. We thought it should be one word, and kind of simple and snappy and something rock 'n' rollish. And so we ended up with Vaseline.

Dan Burke (notorious concert promoter, sometime addict, garage-rock guru, raconteur): I can't remember the first time I met Will, but I clearly remember the first time I heard about him. I was booking the El Mocambo then – 1999, I believe it was. Max McCabe from the Deadly Snakes called me up and told me there was a gay artist named Will who wanted to launch a monthly 'queer rock' night. Max had been sent to me by the Deadly Snakes' Svengali, Chris 'Chico' Trowbridge, and they wanted me to give this artist, who I'd never heard of, a Friday night! Fridays are a big deal. As a booker, you've gotta have shows that you're pretty sure are gonna draw big audiences and produce high bar revenues. Not long before Max called, I'd booked an artist from Los Angeles, a flamboyant queer alt-country singer-songwriter. We even took out an ad in [Toronto gay and lesbian biweekly paper] *Xtra!* for it. Good show, but I lost money. So, queer rock? 'Jeez, Max,' I told McCabe, 'the gays won't leave Church Street, let alone come to a rough-edged place like the El Mocambo.' But Max insisted, and because I had such a close relationship with him and the Deadly Snakes – and trusted their judgment because they were the absolute cutting-edge of counterculture hipness – I said, 'Okay, I dunno about this, but I'll take a chance.'

Max McCabe-Lokos: Dan's nuts, but he's the closest thing Toronto ever had to CBGB owner Hilly Kristal. Sometimes he didn't pay bands the full guarantee, but he didn't keep the money or anything – he just didn't make enough. He did what he had to do to get bands to town. Originally, my friend Chico approached Will about an idea he had. He thought Will could do a gay rock 'n' roll night called Homo-Combo. I think Chico DJ'd the first one with Will. It was never called Homo-Combo, but Will made it into Vaseline and ran with it.

Dave Munro: Ewan Exall was working for Dan Burke, and Dan had taken over the El Mocambo and was running it into the ground. Dan's version, of course, is very different. The place was just not making any fucking money at all. From what I've heard before, Dan claims it was Max McCabe from the Deadly Snakes who'd encouraged him to work with Will. I don't entirely buy that. Before the Deadly Snakes started playing, they were spending a lot of time at our house when shows were going on. Will spent a lot of time hanging out with those guys in the early nineties. But I just can't picture Max talking to Dan and having Dan pay attention. That's the part I have an issue with.

Alex McClelland: Dan wasn't being super committal about it, because he thought it wouldn't be a success, or didn't understand it – nothing like that had happened in Toronto in a long time. The idea was to bring a wide range of people together who would not normally co-exist in gay bars, and to have something exist outside of the Village that had more elements to it than just a DJ playing music. There was conscious effort around making it more of an event.

John Caffery: Will was really intentional about it being at the El Mocambo. He thought it was important to find a place that had a legacy of rock 'n' roll. Nirvana performed there, the Ramones performed there, the Stones performed there – there was a history. Will was such a history nerd that that was really important for the integrity of the party.

Benjamin Boles: It was all about creating a space. I realize more and more how that's at the heart of a lot of movements for the marginalized, because when you're marginalized you don't have a space. Queer kids realized this was their space all along. If anything, during those El Mo years, I saw straight friends, like the Deadly Snakes, realizing that the gay was there all along, and that it was a part of their history too.

John Caffery: I was working at Zelda's at the time, which was a drag-queen restaurant on Wellesley Street. Will and the others

had opened up this whole drag interest. I got this job, and every Saturday we were in ridiculous theme drag. I worked there for five years and he would frequently pop by and tell me what he was up to. We had already started going out to parties where he would see me dance with wild abandon, and he liked that. And he was like, 'I want you to be a go-go dancer for a new party I'm going to throw.' I had no idea what to expect. He talked about how he wanted it to be a revival of Rock n' Roll Fag Bar, which had happened earlier on in the eighties, at an East Village club called the World. And he was like, 'There's this queer legacy in rock 'n' roll that people don't really know about, like David Bowie and Queen – I want to bring that into the foreground.' I was much more into disco and hip-hop, which, to me, was music that was more obviously danceable. If you're going to throw a party, why wouldn't you use dance music? How was I going to dance to rock 'n' roll? I went along with it with a furrowed brow: how is this gonna work? And what am I going to wear? I remember he lent me some leather bracelets with studs on them and I had a vintage Twisted Sister three-quarter-length shirt. I decided that's what I'd wear to the first one.

Alex McClelland: He designed the first Vaseline card, which had an image of a leather daddy, but I thought the card should have glitter on it along with the chains. We bought some grey cardboard and went to my father's office (my father's an architect). All the first Vaseline cards were made there for a while. I had a key, so we'd go late at night and make stuff. We sprayed glitter on these pieces of paper and put them through the photocopier – and we kind of broke the photocopier because it filled up with spray glitter. I always imagine architects coming in the next day and being like, 'Why are all our drawings covered in spray glitter?' Anyway, we thought that each item should be unique. I guess Will was also inspired by that original flyer I had made using old LPs, which was hand-done.

John Caffery: It was January 2000, the last Friday of the month. So it was like: new millennium. Will had such a massive network of

people in his life already, in all these different circles, and being who he was, he'd just bike around and hand out these little cards he'd made that had a chain around them with a classic leather-daddy image. When I showed up to dance, I was floored because the lower level of the El Mocambo was already packed. He had this vision of what it could really be clearly in his head, it seemed, from the get-go. And there was such excitement and a buzz for that first one, because everyone was looking around, everyone had come out of the shadows, like 'Who are these people? There's all these rock 'n' roll queers in the city that I had no idea about.' There was something about being in your own city but being surrounded by new people. The first time, we were dancing on little black boxes. We had one square foot of space to dance. And it was kind of weebly, but it was great, and it was such a success.

Lorraine Hewitt: John and I were dancing on the benches in the back of the first floor of the El Mocambo and on the pool table. People were trying to get us off the pool tables, but we were really into it. Will was loving it! After that first time, he said to us, 'Next time, can you guys dress up a little bit more? And I'll put you in a box? And you can dance with a friend?' And we were like, 'Yeah!' That was our ticket to becoming the official Vaseline go-go dancers – neither of us ever got tired of dancing. We'd spent the past couple of years going out to dance probably three nights a week. So that was really fantastic.

Dave Munro: When we ended the first one, Will was like, 'You gotta come upstairs with me and Dan.' I said, 'No, don't worry about it. If he doesn't give you the money, just let me know.' He went upstairs and Dan's got this stack of cash he's counted out, because they wanted to handle the money, of course. The first couple ones became a severe negotiation because Dan really didn't want to hand over the cash. I was amazed that he had it on the table. I would've figured that it would've been tucked away, that we'd have to go hunting for it, like it was Easter morning. But he actually had it on the table and he's like, 'Well, you did a lot better than I expected. Fuck, I didn't think anyone would come to this fucking shit.'

Dan Burke: That first Vaseline, it was great: $2,700 bar sales, which was very good. And that was that: Will had a Friday every month from me.

Rori Caffrey: While I was living in Japan, I received a letter from him in which he sent me a flyer for the first Vaseline and he wrote about how anxious he was about it. He was all 'I wonder if anybody will show up?' To be honest, I thought it was going to fail. Will wasn't an event promoter and didn't even like hanging out in bars himself. There wasn't anything like it at the time and it seemed like an event there wasn't much of an audience for. But we all know how this one ended. As it became the sexy, crazy, infamous party it did, Will became more and more of a personality – not that he changed or became a different person, but more that people caught on to his awesomeness. One friend I talked to while I was in Japan said, 'Oh my god! Will has become a super-star! He's like Toronto's David Bowie!'

Max McCabe: It was a great night – the Snakes played one and we covered 'Some Girls' by the Stones. Very campy. I don't know much about the gay nightclub scene but I bet there wasn't much going on outside of Remington's or the Barn for cool gay and lesbian people. Or straight people. It was a fun night for *anybody* who wasn't an asshole. It must have been very refreshing to go to a gay club were you could hear the Velvet Underground and not have to listen to RuPaul.

Amber Ternus: Will was really nervous about bringing live music into the queer scene. That hadn't been done. He was nervous that the queer community wasn't going to be like the punk community he was used to, where people just appreciated live music. He really wanted that. It was very brave of him to try it, especially with really out-there artists like Peaches. I wouldn't say she was particularly musical at that time. She was definitely more performance arty. It was totally pushing the envelope yet again. I remember that night because we were all nervous about whether it was going to succeed. Were people going to show up?

Was it going to be fun? Will always wanted a group of us to be onstage and to do performance, so that was a really neat part. It was clever. It meant we all got involved and were very invested in the project. I don't exactly remember what I was doing that night, but I think there was pudding or Jell-O involved.

Alex McClelland: We thought there should be some kind of a host, and I thought doing drag was fun, so Will was like, 'You should do drag.' And his friend Saira McLaren came up with the name Tawny LeSabre, who we thought should be a trashy rock 'n' roll bitch. When I started hosting as Tawny, I had stopped drinking for a year and was a vegan and stuff, but I started to drink in order to be more outgoing. As a drag queen, you have to be the hood ornament of a party, social and chatty. I'm a super, super shy person, so I wasn't very good at being a drag-queen character. A bunch of my earliest recollections involve being hilariously drunk and entertaining people by rolling around on the bar, which people enjoyed. Within the first year of it, there was one night I remember best, which was the night that Peaches – who was a big deal by then – performed. Will had this great idea that he was going to wear a diaper.

Peaches (Toronto-born international performer, pervert, queer icon): I'd been performing as Peaches for about six months before I played that Vaseline. I remember thinking, when I was making my album *The Teaches of Peaches* [released in September 2000], about how the queer scene and rock scene and electro scene didn't really get together. And when I was making that music, it seemed like the quintessential, perfect representation of Vaseline in 2000. The DJ would always play hair metal or Iggy Pop or the Runaways, that kind of rock, and then there was the electro and the loving of the eighties underground, Suicide and stuff like that. It was kind of an improv night, and I was sort of a conduit for everybody to be as shameful as they could. Will came up in diapers and high heels and undid his diapers and then all these baked beans that were supposed to be diarrhea or whatever came out. And then he pulled out a little rainbow flag from his ass and

wiped it off and started waving it — the ultimate shame moment. I was playing some of my songs but I was also just rapping about whatever was going on around me at the time. Shary Boyle came onstage without pants on, just underwear, and she actually had her

period, and just started pissing all over the stage and dancing. And then Andrew Harwood and his boyfriend were dressed as metal dudes, and they'd drilled a hole in a big watermelon and fucked it together. Will created that environment for this to happen, of course.

Andrew Harwood (artist, curator, gallerist, drag sensation): I went to Vaseline a few times when it first started and then Will asked me to host the night. I was scared to death, but he was so nice and I thought it would be fun – which it was. I had a few shots of Jack to get my nerves under control. I wore a garbage bag, white nylons and a giant blond beehive wig I'd borrowed from my pal Elaine Bowen. Oh, and I was carrying one of my 'Expo' dildos as an accessory, which I remember using provocatively on a few guys!

John Caffery: Andrew Harwood was in the garbage-bag drag – literally, wearing a garbage bag – and this weird makeup, and he started having sex with a watermelon onstage. It must have been quarter to two, and he just took his dick out and started peeing on the dance floor. There was a real mix of reactions. Some people were angry and grossed out, and some people were like, 'Yay!' clapping, and like, 'This is what this party needs.' It was this weird scene that happened over the course of a few seconds, and everyone kind of clears, and then the crowd slowly moves, and you're just dancing in a urine puddle.

Alex McClelland: Andrew went up to some random guy and ripped the guy's shirt off his chest and then peed on him on the dance floor. All of these things combined, I think, made up the tipping point of Vaseline: everyone started to know about it, and it became way more packed. Someone at *Toronto Life* wrote about what Andrew did – it was like society gossip!

Dave Munro: It was the third one when Will started realizing that if he was DJing, he might not have to pay out as much money, and he could be paid as a DJ. So that's roughly when he started DJing.

Alex McClelland: When I first met Will, he had a massive cassette collection, which was great but mostly hardcore music, and he had a bunch of records. But he didn't know anything about popular culture. He wouldn't know really common things, like he didn't know any Madonna songs. He got more and more into stuff as he got more into DJing. He started because I'd bought some Technics 1200 turntables and we moved in together and got more and more into records and music together. He wouldn't match beats or anything, because he just played rock songs at first, but he was really good at it. People loved what he played. Originally, he didn't

Vazaleen 2000

really want to DJ at Vaseline, but he realized it was easier, because the stuff that Miss Barbara Fisch played would always turn everybody off a little bit, and the stuff that Rawbert played was always a bit too down and weird, and Will really wanted to cultivate a dance-crazy vibe. So he started playing hits and everyone loved it.

Lynn McNeill: A lot of the energy had to do with lesbians, because they were traditionally much more into live performances, not house/dance music. Probably the most amazing thing about Vaseline was the incorporation, the combining of the worlds, because that didn't happen before. I mean, it happened at SqueezeBox [Michael Schmidt's party in downtown Manhattan in the mid-nineties], and it happened at Cherry in Los Angeles. But this sort of advent of the tattooed rock 'n' roll lesbians of the early nineties becoming part of this scene created energy around it in a lot of ways, because otherwise, it'd just be a bunch of dreary old fags dancing to rock 'n' roll music. It was the hybrid that was so fantastic.

Andrew Harwood: At first I could not get over how un-Toronto Vaseline was. It was super friendly, cruisey and so fabulously mixed. There were dykes, fags, straights, trannies, bi's, drag kings and queens, genderfucked folks and people of colour from almost every community in the city who all came together to party and flirt and dress up! I don't think there's been anything quite like it since then. It was Will's personal energy that made this wonderful mélange of people possible.

Bruce LaBruce: Will magnified a spirit that had always been in Toronto. Usually one night a week, they would have a dyke night at venues. There used to be one at the Boom Boom Room on Queen West. And there was the famous Rose Café in Cabbagetown. There were dyke nights, or special parties at dyke bars – I hung around with a lot of lesbians, and it was always the cool gay boys who went to the dyke bars. Those were some really crazy parties, more old-school gay – really tough dykes and baby butches and lipstick lesbians, all mashed together. At the Rose

Café, I once saw a butch dyke in leather whipping a billiard ball at somebody's head; another time, I saw a fight where a woman reached up and unscrewed a light bulb above the pool table and smashed it and brandished it at somebody. Everyone hates crime and violence, but the occasional fight or people blowing off steam or being crazy goes a long way, too. It spices things up.

Peaches: I remember going to Vaseline and thinking, 'Oh my god. Finally a place where I feel exactly at home.' Especially coming out of the nineties and the indie scene, which was never so queer. It always seemed like the nineties vibe was – if you want to relate it to a drug, it was heroin. It was like, everybody stare at your shoes. I was more performative. I never really felt like I fit in at that time.

Alex McClelland: Will was one of those people who just did things and never questioned people's reaction to them, which I always thought was admirable, and it meant he produced a huge body of work. When we lived in our place at Dupont and Ossington, he would always be sitting on that gross futon and sewing or crocheting, and watching videos, if he wasn't doing something else. He was constantly producing stuff. In the early days of Vaseline, he was constantly sewing all of the individual customized underwear. He'd also be coordinating photo shoots with boys he liked – that's when he did that project with all the different Polaroids of people in underwear. We had an open relationship, and he liked to have threesomes and stuff with people. I don't know how to explain his form of sexuality: he was a bit of a voyeur, but he also really liked cuddling and kissing and stuff. He was really sweet. And he got off on taking pictures of people, so he would do that with different boys around the city, similar to the early days when he would take pictures of skater boys.

Peaches: Underwear's the closest you come to someone's body that's not another human, right? Maybe that was his way of getting super close to somebody, experiencing what kind of under-wear would best suit them. He made a few pairs of underwear

for me. First he made me pink Y-fronts, out of tinselly, furry material, with a satiny waistband and thighbands. I wore those in my shows immediately. He sent me another pair before I came out with my second album, *Fatherfucker* [2003], and they became the centre of my photos. He took a Def Leppard T-shirt and turned it into a pair of Y-fronts with gold trim – it said *Def Leppard* on my ass. And there was a tiny little cock and balls on it. That totally changed the game for me. I had been wearing a dildo that was made by a girl here in Toronto. But that underwear changed everything for me. That was a big feature in *ID Magazine* and stuff like that. People started to make cartoons of me in that underwear, which became my signature piece. They would write *Peaches* on my bum in that writing instead of *Def Leppard*. That became my logo forever.

Cecilia Berkovic (friend, artist, designer, caregiver): It felt like there was something really exciting happening in Toronto, and this was around the same time I was coming into my queerness. Will wasn't very good at tech stuff. I was just finishing off design school so I was super keen. I have this art background, so somehow I started designing cards with Will – he was making them by hand with Alex before that. Will had had a show at the Zsa Zsa Gallery with all his Polaroids on the wall, and I'd gone to see them. He wanted to document them but couldn't get good documentation of that work. And I suggested that instead of trying to photograph it on the wall, we could scan all the Polaroids and then rebuild in Photoshop and then output it that way, as a piece. Our friendship began as a working friendship. I got to know Will through sitting in front of my computer. We'd met at one point at one of the early Vaselines on the main floor. Me and my friend Simone had mud-wrestled in a pool – my friendship with Simone was very performative and public, and it was exciting to have that public queerness. Vaseline was an amazing stage where that could play out.

Lorraine Hewitt: Before the whole roller-derby craze, Will decided to do a roller derby at Vaseline. He was always so ahead of the curve. That was my most terrifying Vaseline. I had a pair of roller

skates I'd never used before that I'd picked up second-hand because they were cute and had yellow wheels and rainbows. I had made knee and elbow pads that were pink and heart-shaped out of some kind of foam. But they were woefully thin. They weren't going to protect me from anything – they were there to look cute, really. All Will's friends were supposed to do a fake roller-derby match and skate around in a line and stuff. I could not skate, we were in a club, and we were drinking. I did my best, but I was terrified the whole time. I was so scared that, when we went outside, I had to go down the stairs of the El Mo on my ass.

Amber Ternus: I started the roller-derby one! I convinced him to do that. We got our skates at the thrift store Buy the Pound. Nobody knew how to skate. We just got roller skates and Will was like, 'Okay, we'll do it!' That's just how he was. He just always wanted a theme and a different something, and some of them were cheesier things that happened in the beginning. Later on, they started bobbing for dildos and all sorts of really pervy games onstage. The early days were a bit more intimate. Sexier too.

Alex McClelland: What I remember most from Vaseline, because I was still living at my father's house and my father lived downtown, is that Will would book these people, and they would end up having to stay in my bedroom.

Vaginal Davis (legendary performer, musician, artist, genderqueer, lecturer, character): I met sweet Will through one of my former Canadian grad students, the talented artist Karen Lofgren, a.k.a. Kara Hunger, at the California Institute of the Arts. My first impression of Will was that he was a male gamine or pixie – he reminded me of the French actress/dancer Leslie Caron, who was discovered by Gene Kelly and made the female lead in the MGM film *An American in Paris* in 1951. It was also through Karen that Will reached out to me to star in one of the first Club Vaselines at the El Mocambo. Will came to pick me up at the airport and treated me to a nice hefty comfort meal at some wonderful old-time boîte. Will's boyfriend had a gay dad who was away on holiday, so I had

his luxury penthouse apartment all to myself. I was in Toronto on that trip for almost two weeks, so it was business and pleasure. Will and Bruce LaBruce helped connect me with a handsome, studly young fellow who wanted to fornicate with me. No one ever tries to hook me up, but Will and Bruce were integral in finding me a man to make my visit extra special. Will was a very generous and gracious hostessa; his lover took me for spa treatments and I do remember receiving a mani and pedi and getting a massage from a humpy French Canadian with strong hands.

Dan Burke: Vaginal Davis was pretty crazy. At sound check I was sitting next to her on one of the wall benches facing the stage and she was rambling on about cock sizes in Hollywood. Vag was a library on that subject. It was funny – Vag was obsessed.

Vaginal Davis: The first time I performed at Vaseline, I performed my classic shrimp ritual, where I lick clean the feet of several virginal boys as a tribute to the goddess religions. Of course, that caused quite a sensation. I also sang songs from my hit album *The White to Be Angry*, and was just a general scandalous hoot.

Alex McClelland: We had watched a documentary about Michael Alig, and [club kid] Clara the Carefree Chicken was in that, so we were like, 'We should get some costumes from Malabar.' Will was probably the cheapest person I've ever seen in my life. But Vaseline started making some money. He rented the chicken suit a couple of times. He had some people dance in it. Will loved the chicken suit, so when he had it, he would run around the city in it. We once went to the Black Eagle wearing it and they didn't like it. He was obsessed with perverse costumes where he'd be invisible. He dressed up as a wolfman once, which he really liked. And there are pictures of him dressed like John Wayne Gacy in that disgusting outfit where he put clown makeup on and covered his face with nylons. He liked being a weird pervert in costumes that covered him up.

Lex Vaughn (artist, performer, comedian, friend): Will would come over at the most random hours. It'd be eleven-thirty and he's like,

'Oh my god. Do you guys have food?' That little hungry urchin. And bitch would gossip! Oh my god, he gossiped more than anyone I knew. He would just come over, eat forty pieces of any food substance and just talk shit and make us laugh and then of course it'd be 2:30 a.m. and he's like, 'Well, I'm off to flyer.' Two cans of paste just clunking against his knees. I never really remember him sleeping ever.

Jeremy Laing (celebrated designer, artist, friend): I guess I knew who Will was before I met him, and I had probably been to one or two of his parties, but I remember seeing him on Church Street, the day of Vaseline, postering for Vaseline. I went over and said, 'Well, it's a bit late, don't you think?' We chatted a bit, and he gave me the poster. It was the Ziggy Stardust one, on the manila paper, with a fluorescent orange silkscreen on Ziggy's face. Later, he told me I was one of the few people who ever came up to talk to him while he was postering, and how he really appreciated that, because most people loved the fun and glamour of the party, but when they'd see him with his wheat-paste bucket, they'd either think it was weird, or cross the street, or … He was sensitive about the labour, and how people thought about it.

Joel Gibb: During university I saw him riding his bike once on the north side of Queen's Park with what looked a big stash of stuff that he got at Buy the Pound. I recognized him from high school, but that's when I finally met him. I guess that was September 2000, and then immediately we all became very close very quickly. It was right around the time I started the Hidden Cameras – the same month I started the band, I met Will.

Maggie MacDonald (sometime Hidden Camera, activist, zinester, performer, punk, friend): Joel and I started hanging out, but Will was already a friend through punk and music and political stuff, and we were always just going to Vaseline. When Joel started the Hidden Cameras, he just went around randomly asking a bunch of people to be in it. He'd ask really great musicians to be in the band, and then people like me who, well, I didn't know how to

play any instruments yet. Eventually, Will asked us to play Vaseline. We had played a couple of shows, and it was obviously a very different thing from what was going on in Toronto music at the time. The late nineties was all straight, white, male guitar rock. It's a bit more diverse now, but at that time it was not diverse, gender- or sexuality-wise or whatever. We had this queer carnival. People were comparing us to the Cockettes.

Joel Gibb: Will came to Rochester, our first gig out of Toronto, where some lesbian math-rock band – oh, Tracy + the Plastics – played. And Will somehow wound up drumming because Matias Rozenberg [then a member of the band], was sleeping. So Will drummed, he tour-managed a bit, he was our promoter, he designed the LP, he was a poster designer for one show. He had so many roles in the Hidden Cameras. He was also a cheerleader. He really was a fan and supported me and was a very early champion of my stuff.

Alex McClelland: Vaseline was still at the El Mocambo, but it had moved upstairs, because it started to get busy, and Will got a cease-and-desist letter from Unilever. It was a little bit dramatic, but I don't think we took it too seriously. We were more weirded out that they'd found out his address, 'cause he got this letter in the mail. The solution was basically still to do the night; we just changed the letters in the name. He talked to Dan Burke, and Dan Burke talked to some lawyer, and then we just changed it to Vazaleen. I think Will wrote a letter back to them, saying he would change the lettering or something. And that was fine. They didn't write anything again.

Luis Jacob: Queer people have had to actively make their culture and community and institutions, because the non-queer world is not going to do it for us. And I love that, I love the idea that you have to create what you need, you know? So I really admired how Will connected with other people who shared a similar spirit, and gave people the licence and the support system to manifest their own ideas within the umbrella of his projects. Like encouraging young musicians or DJs, or the people who did the video projections

One of Will's subway birthday parties

at Vazaleen, or the posters, or the invites, or the hosts and hostesses who would harass the audience and make it all fun. He would set up this framework, but it would be filled in by the creativity of so many different people.

Alex McClelland: There was this sort of competition around people having really elaborate birthdays. So Joel Gibb had a butt-plug birthday party where everyone would have to bring a butt plug, show it to everyone, go to the bathroom and put it in, and spend the whole birthday wearing the butt plug.

Joel Gibb: No, I had a foot fetish party, where we exfoliated our feet in West Wing Gallery. We had pedicures, basically. Then Will had a diaper party to up the ante. Then the next year, I had a butt-plug party to one-up his party.

John Caffery: He had about twenty people over, and we all got in diapers and then we hung out and crinkled around for an hour and a half. Then there was this weird ceremony where we all stood in a circle and the game was like, somebody's going to pee. We had to try to guess who was peeing. I don't know how Will was able to ask these super-strange things of people and they were happy to oblige and just go with it and trust. He was really good at pushing people's boundaries in a fun way.

Alex McClelland: I was really earnest and took it seriously and peed, but I was the only person who did. Everyone else lied. Will's parties would never involve booze or anything, so we'd do something like that to keep people entertained. That's also how his subway party evolved.

Amber Ternus: **More than anything, I will remember Will for his** birthday parties on the subway. Those were very iconic. He just threw it at us, like, 'Hey, we're going to take over a subway car and have a dance party.'

Alex McClelland: **It was pre–social media, before the proliferation** of cellphones. I took his phone book and sat for about two hours and called everyone and left them a message with a time and a station. And then everyone just showed up. The internet's changed our brains so much that you can't imagine doing something like that now. This must have been in 2001. We met at Bathurst station at first, then we rode to the end of the line and back again. It was fun. The security didn't ever kick us off. They said they would be watching us and just waiting for us to leave if we stayed for too long. John Caffery brought a stereo and Mike e.b. brought a stereo, and they would have coordinated CDs on the stereo and they'd stand at either end of the party, which would take up half the train.

John Caffery: **It was pandemonium, mayhem. People were hanging** off the bars and dancing on the seats.

Amber Ternus: **All of a sudden,** there were just all these people there and we all knew each other. At the first party, there were probably twenty-five to thirty people. We just took over the subway car, put on the music and were, like, hanging from the bars, having a total instantaneous dance party, going crazy. We all had such an amazing, fun, creative bond with each other. We were so free around each other. We managed to never

get in trouble. And then they kept getting bigger and bigger until, at the last that I remember, the train was so full, and there were so many of us, it was really like being in a club. We certainly made a bit of a mess – maybe we shouldn't have been as messy as we were on the subways, now that I'm older and thinking about the poor workers who had to clean up. Throwing confetti around, hanging from the monkey bars, everybody trying to do acrobatics in there, just totally funny, being pervy … And then of course we'd all go back to somebody's house and party the night away.

John Caffery: The subway doors would open, and it was like, 'Come on in!' I felt like there had always been this 'Join us' kind of philosophy. It was never about being too cool for others. We wanted to bring people in. And that was part of the culture of Vazaleen. It really did feel like all the freaks could unite and have safe space there. If you can get with the freaks, then we want you here.

Maggie MacDonald: Will was really the spider spinning a web here, creating a community and making a space for that community to exist. Once he started Vaseline, it was like a beacon, and everyone flew to it and met each other there. It was a really special thing. Everything was rich with history, and Will had a real sense of – his whole fascination with Klaus Nomi and these figures from the past gave everything a sense of context: there's another generation of artists that did weird stuff before us, and we're part of a cycle. We're part of a historical community. Just going to his place and hanging out, thumbing through his record collection or looking through his books, you really got a sense of your place in a larger artistic continuity.

Joanne Huffa: At a time when the mainstream was becoming more and more homogenous, Will reminded Toronto that good music is good music, regardless of genre or popularity or decade. It was perfect for those of us who knew most of those songs, but maybe it was even better for people just getting into music, not to be bound by preconceptions. Hand in hand with the music was how

sexy and joyful those nights were. A lot of times when I'm reading about how there has to be a discussion about whether the rights of straight people should extend to the queer community, I think about how positive and happy those parties were. I'm pretty sure all the individuals trying to control other people's happiness have none in their own lives.

Kevin Hegge (filmmaker, DJ, friend, artist): One of the first times I remember going there was with my first boyfriend. I was so nervous based on the sordid orgy I thought I was about to enter – but literally, my life changed when I entered the club. It was fucking magical. There was old-school Super-8 porn being projected all over the club by Scott Berry, and tons of women and men all together, and the old naked dude with the snake tattoo who was never absent in years to follow. There was the smell of what I would discover was poppers in the air, and, most of all, there was rock 'n' roll. Vazaleen was the thing that ended up marrying two central parts of my life – the queer art scene, which is how I knew of Will, and my interest in live rock 'n' roll – and shaped how I would negotiate my interest for the whole next part of my life. I wasn't able to relate to the things I saw in mainstream gay culture. It was all so corporate and institutional, based on all the things that rock 'n' roll rejects. Without Vazaleen, I don't even want to think of what would have happened to me!

Luis Jacob: There's something nice about the way things got a little messy at Vazaleen. That it wasn't all about good behaviour and showing how cool you are. It was just about showing how much fun you were having, if anything. The music was really good. And for me, it was educational because basically all I listened to was electronic music growing up. Guitar music is something I've never been attracted to. But then, of course, you realize that rock is disco – it's often, like, straight-people disco, but it's still dance music, right? And it's riotous and fun. Will was also very much a walking encyclopedia of the roots of different cultural forms of expression. He was interested in how rock actually came out of black music, and the early queer rock musicians, and how

a lot of iconography and styles of music and dance evolve over time as different groups of people adopt symbols and kind of change their meaning.

> *How many cops does it take to shut down the El Mo? Seven squad cars' worth, judging by the parade of cruisers that lined up Spadina just as the club's Nov. 4 goodbye bash was coming to a close. Though club booker Dan Burke was told he had till 4 a.m. to clear out, new owner Abbas Jahangiri – possibly fearing mass destruction to his new investment – showed up shortly before 2 a.m. with a small army of boys in blue. As patrons were forced outside, Burke and Jahangiri began a screaming match that culminated in Burke tossing a pair of sunglasses in Jahangiri's general direction. Moments later, in the club's back alley, Burke was cuffed on charges of assault with a weapon as the arresting officers kindly fed him smokes; he was released hours later and will plead not guilty.*
> – from 'Cops Storm El Mo!,' *EYE Weekly*, Nov. 8, 2001

Amber Ternus: Moving to Lee's Palace changed things because we didn't have the freedom to book the shows the way we did at the El Mo. There was a lot more competition for the nights and the space and the stuff. That was a big frustration for Will, because at the El Mo, there was a lot more flexibility. It wasn't as popular a venue, I guess. And he could have a little more control.

Vaginal Davis: The second time I performed, the club had moved venues and was called Vazaleen. I did a late-night club show singing my song 'French,' which also involves me going into the audience and French-kissing people. The crowd was a bit more bridge-and-tunnel, as Vazaleen was now attracting more mainstream people and looky-loos wanting to slum in the queer scene. I still had fun but not as much fun as when I performed the first time, and I didn't get any sex on this trip, which also affects my fun quotient. Keanu Reeves and his hipster mom came to this performance.

John Caffery: I remember always getting in trouble at Lee's Palace. Some staff still don't like me at all – they think I'm an animal. I'd get up on the speaker towers or jump off the walls. There were some accidents. Once my foot went through the wall. Another time at Lee's Palace as well, that Madonna song, 'Hung Up,' had just come out and Will worked it into a DJ set and I heard that ABBA riff right off the top and I was like, 'Oh yeah, I like this song!' I was at the edge of the stage and did this high kick, and I looked down and realized I had just kicked out somebody's teeth! I was alarmed and concerned but also not very sober, so my first response was, 'Oh my god, I'm so sorry. Can I comp you a drink?' He was super annoyed at my offer. He was covering his mouth, and there was all this blood pouring out.

Lorraine Hewitt: Being a dancer had a huge effect on me. Previously, I was an exhibitionist without a platform: I really loved to go out and take over a dance floor and get a lot of attention, but I wanted to do more with it. I'd always loved performing as a kid, but I didn't really have an avenue or an outlet to do that. And I also didn't necessarily feel like it was something that people would want to see me do. Because of body-image stuff, because of being one of the only black girls in the drama program at my high school and feeling tokenized by the roles I would get … In so many ways, finding punk, finding a sex-positive, progressive group of people, finding the queer scene, finding Vazaleen, helped me to see myself as a desirable person, which had always been denied to me before.

'Gentleman' Reg Vermue (Light Fires/Gentleman Reg frontman, drag firecracker Regina the Gentlelady): Early on at Lee's, Will had a Vazaleen with all local bands, and he asked Gentleman Reg to perform. This was only a year or two after I'd moved to Toronto, and I'd recently joined the Hidden Cameras. But at the time, no one knew my band and it didn't really fit with the punk aesthetic of the night. Vazaleen and the Cameras were this gateway to a whole new life for me: it was a queer world I didn't know existed. And the moment I got into that scene changed *everything*.

Michael Cobb (U of T professor, queer theorist, caregiver, friend): I met Jeremy Laing and Will in short order after I first moved to Toronto and became very close to them; they're the ones who made the city this magical place for me. Part of the ethos of this group of friends who are endlessly programming events is that you have to show up. You showed up, and you danced, and you did crazy stuff. I have these

West Side Stitches Couture Club members. Clockwise from bottom: Will, Alex McClelland, John Caffery, Luis Jacob and Jeremy Laing

incredible memories. Often those memories are about the work that we all did for Will, which was coded as fun – and it was fun in some ways. But Will didn't have a credit card and always needed someone to help him rent cars, and if you were helpful enough to help rent him a car because you had a credit card, you also miraculously were the driver.

Jeremy Laing: He always needed help with something. One of the first times I went over to his place, on Ossington and Dupont, I had to fix his sewing machine. For us, there was a general air of that craft spirit, and getting together in a social context, but our hangouts incorporated performance too. We'd do something where everyone was collectively working on a T-shirt production line and got a weird T-shirt at the end. And then we'd go to the twenty-four-hour IGA next door to his place at 2:00 a.m. and model them and take pictures. We decided it would be fun to

have a sewing gang. That's how we came up with the West Side Stitches Couture Club. It was always about making something, but the objects were typically collaborative. Everyone would show up with a loose idea of what the project was and a miracle bag of supplies culled from everyone's Value Village foraging. You'd do a little piece and then pass it along to the next person. We did a Sash Bash where we drew names from a hat and each person made a beauty pageant sash for somebody else. We did a T-shirt relay once or twice. It was a combination of skill-transference, hanging out, socializing, collaborating and then this sort of funny performative element.

Lex Vaughn: My favourite part about Vazaleen was the games. I love that there was this really twisted vaudevillian sense to a lot of it, which I thought was part of its success. It was like a gay *Muppet Show* meets *Let's Make a Deal*.

Alex McClelland: When he brought Jayne County, she just vanished, before the show even started. I remember vividly that she really wanted cocaine, so Will asked me to try to find and buy her some. Then she got to her hotel, but she vanished and went home, like, she had some freakout. That was a special case, but with queer club personalities, that kind of thing would happen sometimes. People could be super sketchy.

John Caffery: Jayne County was such an oddity. I remember her in the back room of Lee's Palace. She had a bottle of perfume, but the top had broken off. So there was no spritzing, she just poured it on her. It was so gross, and then the whole back room stunk of this cheap perfume that she loved. I tried to maintain the conversation, because she was just splashing it on her like it was normal while she kept talking. I am not a perfume or cologne fan, and I felt like my throat was closing, but also trying to be respectful – she was such a punk-rock powerhouse. When I think of highlights of Vazaleen, it's about the songs, the artists. Seeing the Hidden Cameras emerge was really exciting also.

Maggie MacDonald: In 2003, we were in this period where stuff was happening for the Hidden Cameras really quickly, but we didn't have a steady guide or parent figure to keep us all in the same place on track. So Mama Will came with us on this short American tour.

Lex Vaughn: We'd been touring so hard and so much and to have Will's little face there, we were all so excited. We were in Philly during this crazy heat wave, and we played in this basement with no air conditioning, and it was just a sweaty mess. Everyone was exhausted. It was like three in the morning, and Philly pretty much closes down at eleven anyway. All these Philly kids took us to these fountains in the middle of downtown that had giant gargoyles and angels. And they were shooting out water everywhere, and we all just got naked in the fountains and Will and this kid were making out and we were all basically screaming, 'Will is making out with someone!' It was so beautiful. We were straddling these giant mouths of fountains. The most beautiful suspended moment of youth and sex, of everything that was going on at the time. But Will was finally cashing in, making out like crazy. No one could be happier. And then a week later, he was like, 'Oh, I don't know what's going on with that guy.'

Maggie MacDonald: We played at the Andy Warhol Museum, which was incredible. I remember me and Owen Pallett playing in the balloon room with the big silver balloons, not realizing how lucky we were. It was a really wonderful time. Will was our tour manager on that trip.

Joel Gibb: In Pittsburgh, he stole an Andy Warhol jacket from the Warhol gallery. I have photos of him wearing it. We were backstage in some weird room that had some stuff and he just took it.

Joanne Huffa: Throughout my life, there have been moments so vivid that when I close my eyes I can replay them as clearly as if they're happening now. One of those times was at the Hidden Cameras show at Trinity-St. Paul's in July 2004, which was the

release party for the *Mississauga Goddam* album. The Cameras were arguably at the height of their popularity, and everyone was on their feet, singing and dancing. Most of the crowd knew each other (which is pretty amazing, when you think about it) or at least knew of each other. At one point (I'm pretty sure it would've been during 'In the Union of Wine'), Will, who was a go-go dancer, came up to me, tilted my head back and poured wine into my mouth from a wineskin. He was wearing a balaclava, but I could see his eyes. He caught my glance for a second, which was enough for us both to see how happy we were, how excited that our friends were making this music, and how lucky we were to be part of it.

Beth Ditto (lead singer, Gossip): **One memory I have is this one time when we flew in, and the airline had lost my luggage, and we were there for literally one night. I had put all my show clothes in the suitcase. And Will took us to that place, Honest Ed's? It was the only place open, because it was late at night. It was complete grandma town in there. He took us there and he helped me transform this dress that was like a skirt, with a lace top, and it had a lining, like a polyester lining. I just wore a bra, and we cut holes in the lace top and we made a dress out of it. That's what I wore that night. And shoes that were way too big.**

Michael Cobb: We miraculously found Beth some cute little pencil skirt, a top and these pumps. It was really weird that we could find something that worked so well.

Beth Ditto: Vazaleen has always got a special place in my heart. It was comfortable! Like, it was home. You were on top of your weird game, but you felt normal there. You definitely weren't normal anywhere else, but there, it was like extended family. Berlin in the mid-2000s was so Vazaleen – the aesthetics and the spirit and the way everything was fly by the seat of your pants; people created it on the spot. Whatever it took to get what you wanted, you could make it happen. Whenever I go to Berlin, I always get the feeling of being twenty or twenty-one in Seattle in

2002: people of all ages, from all different kinds of art forms, doing all different kinds of things together. There's always one thing that everybody goes to, although it's not necessarily about being *the* party to be at. It's more about being the place you go to feel normal, and relax, and have a good time. I always say Thursday's the punk Friday, and Sunday's the punk Saturday, because not everybody's out on the street. So it's kind of like Berlin's Thursday, if it were a day of the week, and Vazaleen was like that, and Will was like that. You could tell that everybody loved him. Everywhere you went, all over the world, people knew who he was – especially if they were Canadian and they were queer or punk. It was like the global queer punk scene coming together.

JD Samson (musician, performer, artist, member of Le Tigre and MEN): I remember hearing about Vazaleen probably 2004 or so. I was really good friends with Peaches, who told me about it, as well as Lex and John Caffery and Joel Gibb. We were on tour in 2009 with MEN when we played. I just remember feeling like it was home. It was crazy and wild, and there were awesome outfits – and it was the day Michael Jackson died, so I remember being super nervous to play a cover of 'Man in the Mirror,' but we did it anyways, and the crowd felt like a big hug for the most part. The flyers were amazing: I have three of them framed in my house. And the club just had the best energy ever. There were wasted guys fucking backstage, and Will was super happy and all business at the same time, which I love in a man.

Cecilia Berkovic: Our friendship developed out of making cards and flyers for Vazaleen. Sometimes he'd bring stuff in and he had a very clear vision of what he wanted. Sometimes we'd go through some of my books, or I'd be like, 'I'm really into Matt Dillon. I found all these old posters of Kristy McNichol,' and we'd just use those images. He didn't care. He just wanted it done. And he was like that with [printmaker/artist] Michael Comeau too, with the Vazaleen posters. Will gave you a lot of leeway. He was a total rip-off artist. He had no qualms about reusing images, even if it was other artists' stuff. There was a kind of levelling in terms of

imagery, and this irreverence. He just felt like anything could be appropriated.

Kevin Hegge: Will made the flyers for his other parties into collectable objects that were extensions of the artwork of his parties. Flyers for his new-wave party, Peroxide, would come in the shape of floppy discs or hospital masks, or on keys. Half the time, when he dropped flyers off at the record store I worked at, we wouldn't even know how to store them or display them for customers to take. Who else would make a flyer where portability was an issue?

Dave Munro: I think it was about two years into Vazaleen before he started hating it, because it started to shift from what he initially envisioned. He branched off and started doing things like the electro party Peroxide.

John Caffery: I remember Will talking about wanting to start another party. My reaction was similar to when he wanted to start Vaseline: a little bit of wonder and awe; bit of disbelief, like, 'Really? You already have this party. How can you do a second party?' But I also realized he had this magic power and a vision. And it was very much about a different type of music – electro music – which he and I were both really into at the time. Totally different vibe.

Kevin Hegge: I guess Will's parties spoke to the malleability of the queer scene at that time. Vazaleen was going on, and was kind of the heart of the alternative queer scene – like Christmas once a month, really – but Will seemed unsatisfied with that type of success. He was always pushing forward musically, and in terms of nightlife. In those early days of my friendship with Will, it was the electro-clash moment, and as dismissible as that era of music seems now, it felt really important at the time. There was a vacancy and a punkness to the whole thing – a snotty, bratty, cold, devil-may-care root to that whole aesthetic; it was very empowering. So Will took the success of his big glam-rock night and started Peroxide – an electro night in the dingy basement of 56 Kensington.

Lex Vaughn: I felt like I was going to get gang-raped by a Russian mafia poster child in that place. There was never any toilet paper. You were wiping your ass with a syringe.

Kevin Hegge: The ceilings would drip with the sweat of people dancing. Sometimes the dance floor bordered on a mosh pit – electro was aggressive and hard, and the energy we shared on the dance floor was transcendent because of that. The weird subterranean nature of that club seemed to let us take this moment of our lives to another level.

John Caffery: Fifty-six Kensington was a real dive, and a fire trap, oh my goodness. There was only one way in, and that place got so packed. It was very sweaty – there was always all this condensation everywhere, so the floors were really slippery, which was fun for dancing because you could just slide ten feet if you wanted to. There were artists like Miss Kittin and Fischerspooner that were coming out, and Will was interested in stuff like Afrika Bambaataa. It was a very different sound that he didn't see as part of Vazaleen, and he felt he needed to create a whole new space for that. The flyers for Peroxide were different. It wasn't these slick little cards. He was getting really creative, and he'd find a programmable calculator, floppy discs and things like that, and transform them into flyers. But there wasn't the show aspect of Vazaleen. Rock 'n' roll naturally has a lot of show in it. This felt dirtier – maybe dirtier isn't the right word. It felt underground. Literally, but also theoretically.

Kevin Hegge: It was exclusive in that you had to know it was going on to be there. It was a very specific group of young, faggoty art brats who hung out back then. It was the same people who went to Vazaleen, but there was a totally different energy in that room. It was also always flooded down there, which made it tricky to get to the bathroom, and the owner of the bar would chase you in there and bang on the stall door if you happened to pee with a friend and she thought you might be doing drugs. Oddly enough, drugs weren't a huge part of the scene back then,

as opposed to the rampantly coked-out rooms you'd experience now in Toronto.

John Caffery: Peroxide had a strong following and ran for a number of years as well. Lots of people went to both parties, if not every month, then here and there. But you didn't see the punk or hard-rock contingent. It also felt mixed in a different way. There were a bit more fashion kids there. It was a sound that was just exploding at the time, so for all these people who were excited about that sound, that was the party to go to hear it. Vazaleen had the nudists and the bears and the older dykes and the younger dykes and the arty kids. It felt like such a cross-section of the larger queer community in a really beautiful way. Peroxide felt more specific and niche.

Dave Munro: I think a lot of people saw Peroxide as Will opening up more doors, but in reality, he had started to see Vazaleen as, 'Okay, this is making money, but it's starting to lose what I wanted it to be.' Will had an unbelievable issue with how people were viewing him and treating him because he became a person of significance. He was very much aware, like, 'You wouldn't cross the street to blow me five years ago, and now you have to drop my name when I'm in the room so that I can hear you say these things.'

Alex McClelland: Vazaleen became like a monster that he hated. We started to get lineups. We'd been watching a bunch of documentaries about other nightclub scenes in the world, and through something like Studio 54, we were like, 'Oh, we should develop VIP cards for people.' Which meant that if there was a big lineup, if you had the card, you could just get in. The VIP cards were one way to mitigate it being flooded with people who were just there as spectators as opposed to people who were part of the crew that made it happen. I would also be tasked with having to go into the line and pick out people to bring in because the lines were so big – that was annoying and weird, and I guess it created this sense of elitism. But it was one of the first efforts we made to let people know who the event was for.

Dave Munro: By 2006, the thing was just breaking Will's heart. He'd keep a fair amount of it bottled up. I'd usually get the other half of it, him just going berserk. I mean, he reached a point where he was literally trying to do things that could justify ending it, like Nina Hagen. She was actually the most expensive Vazaleen. If that had broken him, the Beaver would never have come to be. That would've just crushed everything. She was like $10,000.

Luis Jacob: I've loved Nina Hagen since I was little. She's just such a goddess. And then to see her at Vazaleen, when she came out in her rubber nurse doll outfit, with little butterfly hair clips that just kept flapping their wings on her hair. And her giant boots … She looked so incredible! She's not a young person anymore, and it was so super hot, and when you think of her rubber outfit, she must've been dripping. And it was obvious that she had a cold. I remember her singing, and then she'd, like, hork, and then spit this gob of phlegm, and she just kept going. I was like, okay, you are beyond punk.

Lex Vaughn: I remember when he got ESG to play during Pride in June 2005. He was so heartbroken because no one came.

Dave Munro: That one he had done entirely on purpose, because he figured that would be the best way to kill Vazaleen.

Alex McClelland: We broke up during that period, and I was banned from going to Vazaleen for quite a while so I don't remember the end, exactly. After we broke up, Will asked me to stop being part of it till things cooled down between us. But one of the last Pride ones, we were on speaking terms then, and he was just talking about how gross it was, how it had become this thing he didn't want it to be, how he hated the crowd. He decided to stop doing it for a while, and just held one every so often. He would just do the Vazoween on Halloween and also the Shame event during Pride for a little while. But it just became like a monster he didn't want to deal with. And he had stopped focusing on his art as much.

I'm a working-class kid – I've worked in restaurants all my life, and that's what put me through college. I think it's a responsible and valid thing to run a restaurant. It's also a crapload of work! And if someone with money comes in and drops a bunch of money on a meal, that helps facilitate everything we do. There's a scene that has developed at the Beaver. People pop by, say hi to their friends, do their work. It provides total community space, which never happens in Toronto. There aren't that many places where you can come, and just sit and have a cup of coffee and hang out without worrying that you're gonna get kicked out. I've always known a ton of people who've lived in this neighbourhood, but it's changed now. Once there are businesses owned by queer people, run by queer people, people start talking about it.

– from an unpublished interview with Will from 2008

Amber Ternus: As far as I know, Will was planning to buy bars, from the first time he had a job. Probably the first time he heard a band play, he was like, 'I want to open up my own club.' He really had this drive for it. I think he wanted to be independent, and to not have to answer to anybody else for what he wanted to do. That was very important to him.

Alex McClelland: He wanted to do something smaller and locate himself in a different neighbourhood – this was before Queen Street had been totally gentrified. And he was always an entrepreneur; there were always projects. It was a logical extension, once he made a bit of money, to open a business. One of the things that was interesting with the Beaver was that, originally, he had this vision of making it – not a collective, necessarily, but being more radical in his business model.

Lynn McNeill: I was really unhappy at Lee's for a bunch of reasons, and also just getting to the point where I wanted to do something new. I used to throw these huge dinner parties at my house for people, and Will came to a couple of them. I always really, really respected his work ethic, and his ability to pull together a crowd.

Also, when he brought Vazaleen to Lee's, I started spending much more time with him professionally because I was running the place. I knew I wanted to open an event space, and I knew I didn't particularly want to book it, because I'd just gotten out of twenty years of doing that. So Will was a really good idea for that role.

Alex McClelland: Before Vazaleen ever started, Will was pretty close with Megan Whiten, who was the original owner of the Beaver. Her mother, [noted sculptor and artist] Colette Whiten, was one of his teachers at OCAD. Anyhow, Megan and Will had been friends for a long time, and she wanted to sell the Beaver, so they negotiated a deal where she didn't put it on the market, and he and Lynn got it for really cheap.

Lynn McNeill: We disagreed about how we finally opened the Beaver. I remember having a conversation about my memory of what happened, and Will going, 'That's bullshit.' He could be quite direct. I remember saying it had been years; we had been looking for years. I remember, for instance, standing on the north-west corner of Gladstone and Queen, which used to be a car showroom, then a garage, and then it had furniture. That would have been the summer of 2005. At the end of that summer, Megan approached me and said she wanted to sell the Beaver and she knew, because we were friends, that I was looking for something and asked if I would be interested in it. The Gladstone wasn't even open when we bought the Beaver.

Dave Munro: I started tattooing two doors down from there, at Accents of Skin, next to the convenience store that used to be right beside the Drake. When I started working down there, the Angels had just started showing up in Toronto. There were a number of teenage prostitutes still working on that corner. Most of the neighbourhood was still filled with outpatients from the Queen Street Mental Health Centre [now CAMH], from the great outing in the seventies. It was not a favourable neighbourhood. And as soon as you crossed under the Dufferin bridge, it got way worse. So it was funny to hear Will talking about where the bar was.

Amber Ternus: I remember at the time, being like, 'This fucking neighbourhood!' We used to hang out at the Gladstone quite a bit, but people were living west of there in Parkdale and spreading out west more, which was kind of new. But when I heard about the Gladstone getting overhauled and gentrified ... nobody I knew was happy about it. Everybody was pissed and upset. So I thought it was funny that he ended up moving next door to them. I thought, 'It's interesting how this works – you have to adapt.' Will still managed to find the right place to be to make his bar successful. He was never somebody who was like, 'Oh, I'm going to hold on to my ideals no matter what.' He was definitely driven to succeed, and he would make choices that would allow him to succeed, like putting his bar next to a place he knew would be popular. He was pretty strategic. He wasn't going to stick his bar in Parkdale.

Lynn McNeill: We pulled it all together and got it open on February 1, 2006. It ran smoothly right away. We kind of knew it would. It wasn't a risk in that sense because the scene was so coalescent at that time. The Gladstone kitchen wasn't open yet, so the restaurant was actually quite busy. The neighbourhood was really energizing, so there were lots of reasons to be optimistic.

Kevin Hegge: I guess when Will started talking about his involvement in the Beaver it was a bit of a surprise. He presented it to us as a sort of extension of what he had been doing in other atypical party spaces, but as a sort of hub for his ideas. He described it as the thing that it successfully became: a diner in the daytime and a home away from home for all the arty queers by night. Right from the start, it really did feel like a place that we as patrons had a type of ownership over. Those who knew their limits knew there basically weren't any, and anything at all could happen in there.

Cecilia Berkovic: That shift was exciting because Will was a friend, and he was moving to that space. It was going to be like a home base, sort of his bastion of queerness, like, 'Queers are in the west end!' And because the space was so small, it felt very grassroots. At the beginning, it was a lot of family – there was a lot of slippage

between the patrons and the people that worked there, and everyone knew each other. It was mostly young hot queers working there and there were really fun parties.

Bennett JP: When Will started running the Beaver with Lynn, he gave me a dishwashing job and let me have a punk DJ night. Back in the nineties, he'd tried to get me a job dishwashing at the Midtown on College Street, but after my interview, they told him I should have left my squeegee-kid gear at home and wouldn't hire me. I wasn't a squeegee kid and I lived at home, but I guess I was too punk for the Midtown. Anyway, all those years later he finally hooked me up – ha!

'Gentleman' Reg Vermue: When I needed a job, he hired me at the Beaver on Queen West, even though I'd never been a waiter, and I stayed for six years. The Beaver became my world. It was the place I worked, hung out, partied and, ultimately, the first place I did drag.

Kevin Hegge: The Beaver is still emblematic of the ideals and politics that embody the queer movement – the idea of inclusivity, of safety and respect, and of surprise and open-mindedness and the freedom from judgment. I remember once, when we were all hanging on the patio behind the Beaver and some gross jock or

yuppie-type guy came barging through the back door, slurring 'Faggot' this and that, and being generally repugnant. Of course the moron became violent, which was totally unheard of at the Beaver, and all the regulars on the patio overtook the douchebag and threw him out.

John Caffery: The first few years, it was just like, 'Oh my goodness, I'm at a party at the Beaver every

other night!' It was a bit much, but so fun. Will just asked every friend of his to do a night there, so there was everything from Miserable Mondays, where they would just play the Smiths, to Hot Nuts to … dozens of others. The programming aspect of it was so intense.

Kevin Hegge: Morrissey Mondays started basically from the first week the Beaver opened. The first time I was in there with some friends checking out the place, we were sitting with Will – who shared my love of the Smiths – and he said he wanted some chill nights, and that on Mondays you could come in and just listen to the Smiths. We called it Miserable Monday because we thought that was really funny. Will understood the humour in Morrissey's lyrics and we shared a rejection of people's constant insistence that the Smiths were all gloom and doom and depression. We tried to highlight the homoerotic nature of everything Morrissey and the Smiths did, which people tend to ignore. We played Warhol movies like *Kiss* and *Blowjob* and *Heat* – you know, the romantic ones. We played all of Derek Jarman's movies. We played movies about criminals – the gay ones. MM was never busy, but it did end up attracting some regulars who would come from the suburbs or wherever just to geek out, and we wouldn't see them until the next month. It was a rec-room vibe. Will and I would stand there at the DJ booth and sing our hearts out.

Cecilia Berkovic: I felt like I was at Cheers. Everybody would be like, 'Hey!' Hugs and kisses and smoking in the back. Just super fun. It was really home for a very long time.

Peaches: I stayed on top of the Beaver for a little while. And I remember when I came back with my band the Herms, Will was a big fan of Radio Sloan from the Need, who was my guitar player. He had made a cape with a hood and a studded leather strap out of a Judas Priest flag. He was like, 'Radio, I *need* to give you this!' But she didn't want it. So I got it! When he died, I asked if she wanted this back, but she was like, 'No, you love it.' I do love it. It's beautiful, like a druid hood. It's really cool. I wore it a lot.

Queens on Queen Street West during Hot Nuts

Alex McClelland: Will was really good with money, and he'd saved tons and tons of money from Vazaleen, but he was a horrible businessman. I think Lynn had this particular vision of how to run the Beaver, and Will had less of a stake financially in it. I think Will put in $30,000 or maybe a bit less, and Lynn put in double that or more. And eventually Lynn bought the entire building. Will did some poor negotiating with Lynn and didn't really have a business partnership agreement. Initially, he was going to have a say in how the business would run, but then he ended up being the promo guy who would run nights. That ended up being successful, because that gave the whole business credibility. Whenever you heard about the Beaver, you didn't hear about Lynn. It was like a Will-run Beaver. He had all these different nights, and they drew everyone in, and made lots of money, but their agreement, how they shared the profits, was skewed in Lynn's favour. And Will wasn't good at negotiating that. His idea of saving money was saving cash in a box under his bed, which is very cute but not all that practical.

John Caffery: We shared a space near the Beaver at 44 Dovercourt Road called Punchclock Studio. It seemed like no matter what hour – I could drop in at three o'clock in the morning – and there would be Will, postering away: 'Oh my god. This party is tomorrow. I really have to get these posters done.' The more he took on, the more he juggled. It became comical. He had so much on his plate, it was hard to keep up with it all. In the later part of the decade,

he was like, 'I have to finish this because this is happening at the Beaver, and this is happening at Vazaleen, and this is happening at Moustache.' He got really excited about taking over the Remington's strip-club space and having an amateur strip party called Moustache where he'd also had one of his first art shows while he was really into creating underwear. He curated this kind of burlesque strip show at Remington's with lots of different performers, myself included. Luis Jacob, Lex Vaughn, Coco LaCreme … We'd all do a strip tease and get a pair of Will's underwear.

Luis Jacob: In 2002, Will had had an exhibition, a little runway show of his underwear at Remington's, with different people modelling his underwear. It was so beautiful to have his art be modelled on the little stripper stage. And, of course, Will had such an amazing, subversive sense of humour. Like making macramé underwear – it's so pervy. And also to have, like, a model at a strip bar. There's something so unthinkable, almost, about that, which also makes it so wonderful. Big boys would participate, and big girls would also participate – he was conscious about how exclusion happens, and then becomes normalized. He was so much about cutting through that. Later on, I don't remember exactly how we started talking about the idea of Moustache. Anyway, around 2005, we just decided to make it a regular event that would happen once a month, at Remington's.

Bruce LaBruce: Will was totally attuned to the idea of creating interventions in subcultural spaces. Moustache at Remington's was basically that idea, although he did it in cahoots with the management. That was a great party. It was such a brilliant idea to have amateur volunteer strippers mixed with professional strippers. There was just such a nice crossover between the queer punks and adventurous straight people – and mixed men and women – hanging out at a gay male strip bar.

Luis Jacob: That's probably when I realized what a super hard worker Will was. He was part of this collective group running this silkscreening studio. Will never cut corners. He had such a high standard for himself, you know, everything he touched. We'd make the design, and realize it'd be great if it was a three-colour poster, or sometimes a four-colour poster. Which was okay, but it was exponentially so much work for something that would be put up and ripped down in a day, you know? Everything he did was like that; everything had a handmade invite. And that's what made people want to be there. Even if you didn't know Will, if you saw this beautiful poster, you realized whoever was behind this wasn't just some club promoter with money, who just paid someone to print it and put it up and that's it – it's actually somebody who cares about community and loves what they're doing, and you want to be there because it comes out of this care and love.

It was super important that no matter who you were, you didn't feel awkward or like you didn't have a right to be there. In the process of working on Moustache, that's where we really cemented our friendship – you know, you're silkscreening until the sun comes up. It's hours and hours and hours of just drinking pop and silkscreening, and listening to music, but also talking. We talked about queerness and community and music, for hours and hours and hours. And the next day, you'd go and poster, which was also a totally fun thing where you'd feel like you were putting your vision into the world. It was very fulfilling.

Cecilia Berkovic: I never really thought about Will's work as being particularly precious. There was always something kind of DIY

and crappy about it. He was a shitty printer and didn't care. He was really prolific – I was always impressed with how much he got done. I liked that he was into hand-doing stuff at a time when everybody was turning to the computer. It wasn't until he was sick that I started thinking about his work in terms of these precious objects. His stuff in general always felt really throwaway to me, although I thought the pairs of underwear were amazing.

John Caffery: I was always so excited about Will's underwear. I really, really thought it was brilliant. It was Paul Petro that had a show of Will's work, and in the centre of the gallery was this rolling rack of underwear. It seemed like a Black Friday sale. The doors opened and people were like, 'Ah! I want that!' They were frenzied because everything was one-of-a-kind. You'd have to find what you loved and what you could afford and what was your size, so that narrowed down the selection. At openings, sometimes people aren't even looking at the art – they're just talking to each other. Certainly things don't usually fly off the racks. It was exciting to see Will

not only as a party promoter but also as an artist who was able to create work and generate that kind of interest and excitement.

JD Samson: I loved his underwear. Beyond loved it. His relationship to pop culture really spoke to me. I still have a pair of sparkly bedazzled Michael Jackson briefs he made – although I've never worn them, obviously. His work is about meshing queer culture with pop culture, men with women, about the androgyny of life itself. Queering it all and looking at people as if to say, 'And so?'

Peer through the glory hole into The Pavilion of Virginia Puff-Paint, porn superstar of the glittery craft underworld. Watch as this insatiably versatile vision of hand-stitched poly-sexuality tickles multiple lacy orifices with detachable foam-stuffed spandex cocks in a heavily embellished and much anticipated triple crossed-stitch debut release.

— from *The Pavilion of Virginia Puff-Paint*,
Jeremy Laing and Will Munro, 2006

Jeremy Laing: We started collaborating on this Virginia Puff-Paint project, which was a kind of multi-body craft porn star. We arrived at the name in that sort of, like, what's your porn-star name – your pet plus your street or whatever. Mine was an aunt plus a weird craft-like thing. Christie Sequins could have been another one. Or Sherry Glue Gun. But it was Virginia Puff-Paint.

John Caffery: Sometimes something would totally take over for a period. His artwork became more and more elaborate when he did Virginia Puff-Paint and started collaborating with Jeremy Laing. They were encrusting everything with jewels and lace and creating a whole alien sex world – an ornate, decorative sex world.

Jeremy Laing: For Will, the underwear was a little more private and smaller-scale and personal, and Virginia Puff-Paint was a way of expanding that approach to include much larger dimensions. I had sewn forever, typically making clothes for myself to wear with friends, and I had gone to fashion school, and I was really just

bored of all that. For me, it was a way of engaging with the act of making and sewing, but in a different context. It helped me reframe my desire to do it. And aesthetically, we just went to Buy the Pound and bought every pink, frilly, lacy cushion, lingerie, bedspread, panty, lace everything, and made this weird sex installation.

Andrew Harwood: I used a panel from their installation to promote *C Magazine* at the Toronto International Art Fair at our booth, and the organizer of the fair at the time made us move from the most prominent spot to the least after we had already installed the art. This horrible gesture on the behalf of TIAF was great inspiration for starting the Toronto Alternative Art Fair. The organizers of TIAF were not from Toronto and didn't realize the importance of Will and Jeremy's work.

Jeremy Laing: For me, the project was about being deliberately tacky and gauche, and kind of grotesquely hideous – Virginia Puff-Paint is an impulse I can't really entertain in business. There's another pursuit there, around how it has to look. So the aesthetics served a purpose, and for me, that made sense, and I related to it.

Margaret Munro: My grandfather on my mother's side had been injured in the war, and he did some amazing needlework. He did samplers. He made one that was a rose, which was just beautiful. It was really thick embroidery. So when you looked at some of Will's art in which the needlework was elaborate, it was sort of like, 'That looks very familiar.' My father was an entrepreneur and he was a pattern maker. He did industrial patterns for machinery and stuff. But he had the same kind of ingenuity. He did a lot of his work in his sleep. He would process how he was going to work on something, and he'd wake up the next morning: 'I got it. I know how to do it!' There are a lot of similarities between him and the boys in how they approach things and the way they do things.

Saira McLaren: Will was a groundbreaker in his art. His work actually dialogued with contemporary art being made in the world – Toronto was so provincial, even in the alternative downtown

Will and Jeremy Laing in The Pavilion of Virginia Puff-Paint

scene. No one at that time was questioning the boundaries between Art with a capital A and craft. He was such a gay feminist, using domestic practices in the context of contemporary art.

Cecilia Berkovic: The thing I loved about Will was that he was such a champion of Toronto, in this way where he was like, 'I'm not going to move to Berlin. Just bring here what you don't see here.' He had an amazing gift. He was an amazing civic-glue person. Just look at the people he brought to town over the course of ten years: it's queer history. It's punk history.

Jeremy Laing: With the Beaver, he just was thinking about a grounding point, like, a physical lightning rod for all this energy and goodwill and community he had instigated and created. It made sense to ground that in one specific spot.

Margaret Munro: I remember driving him down Queen Street, and he looked at the Beaver and said to me, 'I created that.' I said, 'Yeah, you did, Will.' But it was more awe, like, 'I did that?'

Ian Munro: Obviously, a lot of stuff happened there and wasn't planned. But most of what took place at the Beaver was a germ in his brain at some point in time.

Margaret Munro: He was always busy doing things and enjoying life. He was doing what he wanted to do. It was so important for him. He found that he lost friends when he came out and that wasn't going to happen to him ever again. It was crucial to him that people should be accepted, and that's why he became involved with the Youthline for a long, long time. He was beloved, yeah, but it really used to bug him that people would want to be with him just so they could have some kind of status. He wanted to be accepted as himself, not as a celebrity. He wanted somebody to know *him*.

Alex McClelland: I was always excited when Will had dates with people, because Will was not the most proactive person in terms of hooking up with people. You'd think he would get tons and tons of action and boys throwing themselves at him, but it was the total opposite. It was really hard for him to hook up with people. So I was really excited when Will and Peter started going on dates. They met at the Beaver. And Peter had moved here from England, and had previously lived in Australia.

Peter Ho (primary caregiver, boyfriend, confidante): I had been in Toronto for two and a half months. I didn't really know the scene. I arrived on my birthday, so we had a little cake and went exploring. My friends took me down College Street, Dundas, Queen, and said, 'Okay, now we're done.' After living in London, being from Melbourne and travelling to all these places, I was like, 'What do you mean? That's it?' I guess they thought this was the nexus. I went out exploring on my own. I went to Church Street. I went to Little India. I had met a girl named Katie who wanted to go to the lesbian night on Sundays at the Beaver, so we went there and were drinking wine and chatting when Will came in, just back from roller skating. I'm quite shy, and Katie is more outgoing than I am, so she went over and started talking. I sat by myself, thinking, 'Oh, she'll just go talk to them and come back.' But she didn't. So Will said, 'Why don't you invite your friend over?' He kept prodding me with questions, trying to figure me out. I told him I had just moved to Toronto and that I was thinking about moving back to

Melbourne because I didn't think Toronto was my scene. I said it felt small and cold. I still kind of feel this way about Toronto sometimes – if you don't know the community, it's really hard to break into it. He said he had lived in Toronto for quite a long time and could take me to a few places if I was interested. And I said, 'Sure, why not?' I had nothing to lose. And I was wasted at that point.

Dave Munro: At the time, Peter had no knowledge of Will, which was kind of essential. Finally, Will was like, 'You want to hang out when I get off work?' Peter said, 'Okay, well, I'll probably be home by then.' And Will was like, 'All right, I'll come over to your house!' I'm sure Peter was thinking, 'Douchebag buys me one drink and he's coming over to my place?' Of course, twelve comes and goes, and finally Will phones. He just had no concept of time. He never did. And it only gets more awkward. Peter was like, 'Are you serious? You want to come over *now*?'

Peter Ho: He had texted the day before, then messaged me the day of, saying, 'I'll come over around six.' I said sure. I think in his mind it was first of all a booty call, which was fine by me anyway. So I waited, and at six he didn't show up. I texted him at six-thirty: 'Are you still coming over?' He said, 'Yes. I'm just running late. I have a few things to do.' Seven o'clock came. Eight o'clock. Nine o'clock. Ten o'clock. And he said he was still working, that he worked at the bar. And then he said he had some silkscreening to do. *Then* he had to go meet up with someone, drop some food off somewhere, go see a band and then he ended up at my place around midnight! If you know him, that's always been the story with Will. I *didn't* know him, and I don't know why I was so patient. Normally I'm not. Then he stayed over. It was really nice. We had sex. That was our first hookup, I guess.

If that was a Wednesday, he called me on Friday to hang out again. Our first date was him teaching me how to silkscreen, and then we went out for dinner. That was when we started to talk. I think he was more curious about me because I didn't know anything about him – I also didn't know anything about Toronto. But we had similar thoughts and interests. He loved that I was

Australian. I don't know how it was brought up, but we were also both in Boy Scouts. Heavily into Boy Scouts. So we spoke about Scouts and knots and crafts. Mostly, I remember him questioning me a lot, just trying to figure me out, which was fine for me because I enjoyed flirting with him. We definitely had crazy chemistry to start off with. I couldn't really understand him either. That made it more interesting for me.

Dave Munro: Of course, Peter didn't know that Will was part owner of the Beaver. He just thought he fucking worked there. And that's exactly what Will told him for the first three months that they were dating. 'Oh, and sometimes I DJ.'

Peter Ho: Shortly after our first date, we spent a lot of time together. But it was only one-on-one time. We hardly went out. That was the start of our intimate relationship. It was a lot of cuddling, a lot of talking about what we wanted in life. He started to open up more about himself, but didn't tell me anything. He said he was a chef at the Beaver and occasionally threw parties down there. But I didn't know anything else. The thing wasn't simply that Will was not *just* a cook at the Beaver but that he was so many more things. So I would find out that he was a DJ, and then time would go by and I'd meet someone and they'd be like, 'Will's also an artist.' Oh! Okay! He's also an artist! And more time would pass, and they'd be like, 'Oh, actually, Will owns this bar with Lynn.' It was gradually, through meeting his friends, that I found out more and more about him. About three months in, my friend Katie said, 'Well, why don't you just Google him?'

Dave Munro: Peter didn't know Will did any form of art, until Will was stressing over some shows he had to put together, maybe five months into their relationship. Even then, Peter didn't realize. He had no idea who 90 percent of these people in Will's life were until Will got sick and landed in the hospital.

Peter Ho: I grew up in women's shelters in Melbourne. I had a really rough upbringing. And because of it, I ended up raising my

siblings as well. I didn't know that I was queer until I moved to London, because it was the first time I was able to experience going to a bar, which was at the age of nineteen. And so I also didn't have any reference to pop culture whatsoever. We weren't allowed to watch TV in the women's refuge. I knew nothing about music. I knew nothing about anything. And this really fascinated Will because he was like, 'You're such a blank canvas. You know nothing about anything!'

Later on, Will said that it was very humbling to meet me because he had been on so many dates with people where he had to remain 'Will Munro.' People expected so much of dating someone who was famous, which is why he kept that part of his life away from me for so long, as much as possible. He said it was the first time since Alex that he was able to just be himself. It was hard for him. I could see the struggle. He really loved the fame. He did. There's nothing wrong with that. But I feel like at the time he met me, he was really ready to settle down. He was lonely. He had made this silkscreened print, which I still have at home. It was of one of these tags at the back of a T-shirt – you know, 100% cotton, blah blah blah – but then at the centre in blue, it said, 'Hurting from a lack of love.'

The universe is drawn in circles. The memory of chariot wheels clacking across small stones foreshadows the asp's death as he wraps himself around the wheel. He is crushed by its embrace. The air crackles when Ra is within. And sailors who've known only cities by the sea and the whip of the rope and sail, come to moor at last amid a crush of flowers, and rejoice and weep and go on. The days before and the days after fill with the odor of pomegranates; the heart ripens like fruit and falls and breaks. Sweet meat for the lips of gods. On such a day one glances into the sky and finds the eye of Ra looks back. One finds loaves of bread on fine reed mats and the eye of Ra looks back. The air crackles. The sun beats on and on and on.

 – from *The Egyptian Book of the Dead*, trans. Normandi Ellis

i wanna go to heaven
i wanna live in a mansion
i wanna look so handsome
i wanna go to heaven
just to get you all dancing

 – from 'Heaven,' by Ssion

It was a balmy, hopeful Friday evening before Victoria Day, the first week that year that spring felt less like a tease than a guarantee. There was a faint mist in the air, but no rain – the hazy hours around dusk were a welcome aside, wedged between the parentheses of showers. In the northeast corner of Trinity-Bellwoods Park, above the tennis courts and the dog bowl and away from the hippie acrobats whose makeshift tightropes were strung taut between pairs of trees, dozens of mourners made their way across the field. There were kids in strollers, puppies with hanky-code bandanas, and sad faces who were mostly more familiar from bars after dark.

People came steadily, in small groups, unsure where to look or stand, forming an awkward oblong. They murmured hellos and exchanged hugs. They swayed and sighed. At some point, some kid – maybe one who worked at the surly record store a few blocks away – produced a portable stereo, and the tinny music, which sounded tuneless as it filled the great open space of the park, helped some of the tension dissipate. Who knows what was playing? It might've been Ssion; it might've been Lesbians on Ecstasy. It might've been Morrissey, or Limp Wrist, or the Hidden Cameras. There were no dirges – whatever the songs, they were celebratory and exuberant. A toddler ran around the field, kicking a soccer ball and shrieking with great peals of laughter.

It was hard to know who was in charge. This community, these satellite communities, were inured to organizing, to activism, to showing up, paying cover and aligning ourselves with the right cause. This was a group geared toward practical solutions and tawdry nightlife dramas – not a group accustomed to inexplicable loss.

As the sun began to set and the overcast sky purpled, the steady shuffle slowed to stillness. Unexpectedly, it was his brother who stepped forward to speak first, who was brave enough to swallow his own consuming grief and reach out across the misshapen circle of kids, confused by this strange new kind of sadness. Someone pulled a handful of fireworks out of a knapsack, and as dusk fell, pockets of people instinctively inched back en masse as flares went up and arced over the field, leaving a trail of sulphur and sparkles in their wake. The fireworks went off, and that tinny stereo blared something trashy and glam, but that welcome voice cut through the quiet commotion. 'If anyone wants to talk about Will, to share any memories of him or tell any stories, you can do that here.' It was May 21, 2010, the evening of the day of the end.

It wasn't news that he was sick – it was impossible not to know with someone so popular, so vital, so loved and so visible. When he first became ill, two years earlier, word rippled slowly through the queer grapevine. Cancer wasn't an unknown quantity, of course, but it seemed unfathomable that someone like Will, a clean-living straight-edge kid who got more done in an afternoon

than most folks accomplish in a year, could possibly be thrown off course – let alone stopped – by such a mundane, unimaginative force. In the months and year after his initial diagnosis and that first surgery, you'd still see him at the Beaver now and then – once he was there DJing, looking smaller than usual, and paler, and bald, maybe with a hat obscuring the scar across his scalp. But his presence was less constant; he'd ebb and flow.

Bits of information made their way through the community as Will's health was in flux, along with a surge of support. At first, everyone clamoured for a piece of him; as time went on, and the logistics of his illness grew more serious, and the VIP list that granted access to his bedside became increasingly abridged, many people stepped back. Those closest to Will, the friends and family who created a remarkable circle of care and caregivers around him, didn't have that luxury. When he finally entered palliative care, the news trickled down through a casual email, and it was shattering.

This was a generation lucky enough, privileged enough, to have come of age at a time when AIDS had shifted from an epidemic signifying certain death to a manageable, treatable illness. There'd been encounters with death, sure, in the form of heart-breaking suicides, accidents, overdoses and the occasional sudden tragedy. Chronic illness too – the challenges of living with a disability or a compromised immune system. But this unexpected, unexplainable, logic-defying trauma, suffered by someone to whom so many people felt such a great connection, was devastating. It upended the queer community in Toronto, and irrevocably changed the city's subcultures.

Vaginal Davis: The last time we hung out was in Berlin where I moved to from my birth city of Los Angeles in 2006. Will came to visit in 2007, and we had a fab bruncheon at this restaurant called Frida Kahlo with Joel Gibb and Peaches. Will and I talked about him designing the sets, costumes and production design for a new piece I was working on called *Orifice Descending*. Sadly that never came to fruition.

Alex McClelland: Will and I went to Berlin in 2007. I had been in Switzerland for a couple months, and we decided to meet up in Europe. We were staying at Joel Gibb's house. This one day, we were going to go see that castle outside of Berlin. We had made borscht that morning. Then we went on the Metro and Will started to feel really dizzy and out of it and weird. Then he just started violently throwing up. He had to throw up in the garbage can in the Metro stop at Alexanderplatz, in front of all these people, and he just couldn't stop. We assumed he had food poisoning from the soup we had made, because Joel was also saying he felt sick.

Joel Gibb: It was really an early sign of his tumour. It had nothing to do with my food poisoning. It was completely different. But we had similar symptoms. He was throwing up too. He was really out of it. He didn't even remember throwing up half the time. And I was worried. It just didn't make sense. Soon after that, his temperament changed. He got a bit more cranky – I mean, wouldn't you be cranky?

Alex McClelland: Will had been getting kind of confused, and I had some strange conversations with him, where he was totally out of it and really weird. He told me about how he'd been having these things where he would pass out, totally cold, and Peter would find him on the floor, and eventually took him to the hospital. At St. Joe's – which was close to where he lived at the Beaver – I think they assumed he was a drug addict or something, and had OD'd. They were really awful to him. He was really skinny and he was so pale anyway. He hated tanning, or being in the sun. He liked to get up after the sun had gone down, stay up all night and go to bed at nine in the morning. And even if we went sunny places, he would wear a big sun hat and sunglasses.

Lex Vaughn: I'd always been really concerned with Will's comfort, even before he got sick. Then he started acting weird, when the tumour was there but we didn't know it, and he started wearing the same clothes for a few weeks, and got really tired. We assumed he had the flu or something. One day I was massaging him, and

Will, flanked by Alex McClelland (left) and Peter Ho

he kept saying, 'I can't get comfortable,' and I felt really sick afterwards. There was something wrong.

Jeremy Laing: I remember Will as being not quite himself at the Beaver, before his cancer landed. We'd made plans to hang out together in a way that we hadn't done for a long time. We had dinner at the Beaver, and I remember him not making sense, and just being really tired – and tired of how much he was working. He was working there every day, and then fixing the sound system for whoever was working there later, and also DJing later, after having cooked all day. The Beaver became a real anchor for him, like a ball-and-chain kind of thing. That's the thing I remember most: wow, he's really, really beat. This was maybe a couple weeks, a month or two, before it became clear that something really serious was up.

John Caffery: Something was funny with Will. I remember having a conversation with him in front of the Beaver, and his sentences were jumbled, and he seemed confused. He wanted to talk, but he wasn't articulating himself clearly, which was really uncharacteristic. But there were no physical symptoms at that time, so it seemed an easy thing to dismiss as 'You're tired,' or even 'You're human, like the rest of us.'

Peter Ho: He went up to see his mom on Mother's Day, and he cooked for them and then he said he couldn't eat. He just lay down. Later, Margaret said it was strange because he kept opening up the cupboards to look for things but he should've known where they were. And then he went to lie down, and she could see that something was wrong with him, but she didn't know what it was. When he came back into town, I just remember him throwing up a lot, and then he had a seizure upstairs in the apartment. So I ran downstairs freaking out and got help, and we immediately took action, and the ambulance came. Then I called Margaret. We knew about each other, but we had our first transaction over the phone. She said, 'Yes, you're the Australian boy that Will's been talking about.' I said, 'Yes, nice to meet you.' And then she told me her side of Will being weird up there and I told her my side.

Margaret Munro: Will knew never to call me after eleven o'clock at night because I was normally in bed. But after he had passed out and they had taken him to St. Joe's, he had Peter call me, and Peter said, 'Will just wants you to know he's fine,' and this was like one o'clock in the morning. I said, 'Beg your pardon? What are you talking about?' And then it was like, okay, red flag. It was his way of reaching out.

Dave Munro: I got a phone call at six in the morning. She's like, 'Some guy named Peter who says he's Will's boyfriend phoned up last night, said he took Will to the hospital, he's okay. Now they won't answer their phone.' So I start phoning, and I get Will and Will's actually in the bathtub, and he's laughing hysterically. He's just like, 'Oh, shit. I can hear Mom. She's banging on the door.' I said, 'So are you getting out of the tub?' And he's like, 'No. Peter's there.' So Peter opens the door and just gets overwhelmed by my mother, just complete mom swarm, immediate bear hug. I was still talking to Will and he said, 'I'm fucking fine. I had a cold for three weeks and passed out. Didn't have any fluid while I was working. Didn't eat anything. Just exhaustion. They stuck me on an IV. I'm home. I'm cool.' He's still killing himself laughing because he can hear Peter and little snippets of my mom.

Margaret Munro: When I came back on Tuesday, he came to meet me in the parking lot. He'd been riding his bicycle and he had colour in his face and looked really good. And then he sat down and passed out. He talked to me for five minutes and passed out. I said, 'Okay. I'm bringing you up north.'

Dave Munro: They were driving and they had just gotten outside the city when he blacked out and started vomiting on himself and having convulsions and wasn't making any sense. He'd become a little more coherent, and then it would happen again. And she's like, 'Screw it. I'm not going to go to the hospital in Toronto. I'm already outside of Toronto. I might as well just book it.' And luckily they went to the hospital in Meaford because they could get him an MRI immediately.

Margaret Munro: Part of his problem is the fact that he was left-handed. With where the tumour was, it should affect your speech and he shouldn't have even been able to get out of bed, but because he was left-handed, he must have worked out of the other side of his brain. Even in Meaford, the doctors, they didn't know what was wrong with him. One doctor didn't understand why he was having seizures – that's why she sent him to have the CAT scan. She was stunned by the results. Finally, she said, 'The doctor's waiting for you in the ER. You better go,' and Will said to me, 'I'm DJing tonight.' And I go, 'I don't think so, Will.' He said, 'Yeah, I'm DJing. I have to go to your house because I have to phone the Gladstone and I don't have the telephone number.' 'But the doctor's waiting for you.' 'I don't care.' So we went. By the time we got back to the hospital, the doctor met him at the side entrance and she had a wheelchair, and she started running. He goes, 'What's your problem, lady?' She comes outside and says, 'While we're getting him ready, can I talk to you?' I said, 'Sure.' And she said, 'He could be dead in five minutes.'

Dave Munro: That's when they came back upstairs and were like, 'You have a seven-centimetre tumour in your brain. We don't know how you're standing up.'

Margaret Munro: Will said, 'Well, what are you talking about? Do I have three weeks, or five weeks, or ten years?' And the doctor said, 'You'll be lucky if you're still with us in three months.' Will started swearing, and I said, 'Finally, he understands.' I was stunned. Absolutely stunned. When I brought him to the hospital, all I knew was that I had to get him up there for someone to properly look at him and diagnose the situation. But he could've dropped dead riding his bicycle. That's the scary part.

Dave Munro: I was in the middle of a tattoo when my dad called. That was the sixth phone call from my father in ten years of me living in Newfoundland. It was like, 'Why the fuck is he calling me at work? What the hell's going on?' He said, 'Your brother's in a hospital. He collapsed. They say it's something serious. It might kill him.' I'm like, 'What the hell's happening?' And he's like, 'I don't know. No one tells me. No one tells me anything. Your mother told me to call you and I'm calling you.' All right. So I go back to the guy I'm working on and he's like, 'What's going on? Do you have to stop?' And I'm like, 'No, no. If this isn't going to get any more coherent, I might as well keep working.' So the phone rings again and it's my dad. And I'm like, 'Do you know what's happening?' And he's like, 'Yeah, your brother might die. He's got a brain tumour. They're going to rush him down to Toronto for surgery.' I booked tickets on the first flight out, and I didn't sleep that night. Got to the airport and I'd forgotten my ID. Three-month-old child in hand, running around. Absolute fucking buffoonery.

John Caffery: He had to be airlifted back to Toronto Western Hospital. I don't remember how I heard he was in the hospital, but I remember rushing to the hospital, and there already being a group of people there, a *large* group.

Alex McClelland: Will was always popular, but this was the height of him being *very* popular. It was kind of hilarious and simultaneously tragic. A couple of us had to manage how many people were allowed to visit him, so it ended being another fucking VIP-

list scenario to get into the hospital. And it was like that from then on until he was dead.

Peter Ho: I remember seeing Will in the hospital and then turning around, feeling weird, going outside and looking down, and the whole room downstairs was full. It was full of people and someone came over and said, 'Oh, these people are here for Will.' And I'm like, 'Why? What's going on? Why is everyone here for Will? How does he know this many people? How did they find out so fast? *I* just found out!' It was a sea of so many different people from different places. I was blown away. I just remember being so scared. The whole hospital was full. It was crazy to me. I went downstairs to the pharmacy, the only place that was empty, and over to the little waiting area where you wait for your pills, and Margaret was also hiding there. It was just me and her, and she was like, 'I'm overwhelmed by how many people are out there.' We both sat there and kind of bonded in our strange way. And then from that point on, it was a process of understanding who Will was, as well as understanding him having cancer.

Dave Munro: When we got off the plane, there's my mom. And my partner, Laura, says, 'Well, here's your grandson.' My mom just

Will with his nephew, Maddox, at his parents' house in 2008

starts losing it, and says, 'Maddox is beautiful. At least he got to know his name.' And I just feel my heart sink. My mom can't stop crying, she's not getting a word out. I'm inches away from trashing the entire airport. I'm crying and I'm sobbing and I'm starting to swear very loudly. I turned to my mom and everything's in the past tense. And I'm just like, 'When'd he die?' And she's just like, 'He's dead? How did you find out he's dead?' And

I'm like, 'You're fucking talking in the past tense.' After that, the drive to the hospital didn't really seem so bad.

John Caffery: There was no gradual process by which you could get used to the news. Suddenly, it was life-threatening. It felt terrifying. And as with so much of Will's life, there was a guest list, and you were trying to figure out, like, 'Where do I stand?'

Andrew Harwood: It was insane at the hospital – there was a lineup to visit him! Everyone was in shock: we were all in disbelief that this clean-living young artist could get cancer. I remember remarking to Bruce LaBruce that Bruce and I had both done pretty much everything, so why the fuck did *Will* end up with cancer?

Lex Vaughn: At the hospital in Toronto, he was initially misdiagnosed with this rare children's tumour that had the word *primordial* in it. I think he had one unnecessary procedure. But he bounced back so fast from those things. And the cancer that he ended up having, the glioblastoma tumour, it's one of the two worst cancers you can possibly ever get. But it's usually reserved for white men in their seventies, and you're usually dead six months after you get it.

Maggie MacDonald: Glioblastoma multiforme is a primary brain tumour, meaning a brain tumour that originates in the brain. Brain cancer that comes from other parts of the body behaves very differently from brain cancer that comes from within the brain. If you have cancer from other parts of your body and it migrates to your brain, you can treat it in ways that you can't necessarily treat brain cancer. There are some similarities, but it's a bit of a different beast. But, in the end, Will had GBM. One of the main treatments is that they take out as much of it as they can, and that will usually buy the person six months to a year of life. With young people, they can be more radical with how much they take out because you rebound.

Cecilia Berkovic: I met Will's parents for the first time that day. Such a strange set of circumstances to meet someone. Everybody

The brothers Munro

was so on edge. Fucking brain surgery. If he makes it, is he going to remember anything? Is he going to be paralyzed? Is he even going to live? There were just so many questions. And I remember it was sunny. We walked through Kensington Market, just waiting. And then he was fine! I visited him the next day, and he had a giant thing wrapped around his head. It was just amazing to me that somebody's brain could be totally fine, like, 'Hi, how's it going?' He knew my name. He was so lucid, it was shocking.

Dave Munro: Will was lying there, opened up his eyes, and he's like, 'What are you doing here?' And I'm like, 'I came to see you.' And he's like, 'Dude, that would've been a last-minute ticket. That would cost so much money. You could've waited. I would've called.' He asked if he looked fucked-up, and I said, 'You look like a Q-tip.' He started becoming more coherent and talking. Doctor came in, and three days later he walked out of the fucking hospital.

Alex McClelland: He was at Western Hospital for his first surgery, and then that day, the same day, they had him walking. He walked up and down the hall. In something like a few days, they sent him home. I didn't understand brain surgery worked that way.

Peter Ho: At the time it was less about the diagnosis of the cancer and more the fact that everyone thought he was going to die that

day, because the surgery was really intense. We weren't thinking about what sort of cancer it was. So when he came out after surgery and was okay, it was more of a relief than anything else.

Michael Cobb: After the first surgery, he was out of the hospital thirty hours from the moment he checked in. He's in his platform shoes, he has a huge gash in his head – like, major emergency brain surgery – and we're walking out of Toronto Western. Will was wearing his cap. And it was so confusing, because you're just like, 'Maybe everything's fine now.' Bouncing back from brain surgery is pretty astounding. It's actually the only effective method of treatment of any sort. The only way they were able to give Will more months was to demass the tumour, and that's why they eventually did four surgeries.

Maggie MacDonald: Even if you get the main blob, GBM sends out little tentacles all over the brain. You can't get it all. And then it continues to grow. With traditional chemotherapy, most of it can't cross the blood-brain barrier. So that's another issue. GBM survival times haven't improved a ton in a long time. Any innovation in treatment would be amazing.

Peter Ho: There were a lot of heated moments arguing back and forth, because Margaret wanted to take Will back home. People were trying to figure out our relationship. 'Who is this boy? Is he someone who's going to stay to help or is he going to run away? What's his deal?' I think a lot of people, because everyone's so lovely, they didn't say it like this, but they sent a message of, 'You know, it's okay. You don't have to be here. If it's too much, it's too much.' I've had so much time to process that moment, and I'm like, 'Why didn't I just step away?' I didn't understand. It has a lot to do with my natural caregiving role when I was younger. But even when people were hinting that it was okay for me not to be there, it never registered. It didn't occur to me to walk away. I also didn't care that he had a giant scar on his head or that he looked weird after going through chemo and radiation. He was always so alien-like anyway. This is the truth of my attraction to

him: yes, I was definitely attracted to his body, but it was less about that and more about *him*.

John Caffery: They did the procedure, and he went into a real hole and withdrew. It was totally unlike Will – he'd always been so social. Suddenly he wasn't returning messages. I remember Lex and I went to his apartment, and he was just, like, catatonic, watching daytime television. His apartment, which was on top of the Beaver, was *so gross*. It was not a good place for someone who has cancer, to say the least. But he just seemed to be in such a daze, so stunned and shocked from all this happening, and at that point, unable to cope. We tried to go through and clean, but mostly, we were like, he needs to get *out of here*.

Alex McClelland: Everyone thought Will recovering above the Beaver in his shitty apartment was a really bad idea, so he and Peter moved into my mother's house on Beaver Ave.

John Caffery: As he started to come to terms with his own mortality, he got it into his head that he wanted to have another art show. I remember being so concerned with his health, and wishing he would slow down and concentrate on healing. Will had this vision in his head, he had to carry it out, but everything was so precarious at the time that it was really nerve-wracking to watch him invest all that effort in his art practice when you just wanted him to get better.

Alex McClelland: On Will's Facebook page, he has this photo album called 'Brains.' That's from the first brain surgery, which didn't heal properly. They had done something wrong, and he developed this thing that was basically gushing out of his brain and would heal into a weird blob on his head. We called it the Cornflake, because it was really flaky. I would rub stuff into the Cornflake and he hoped it would go away. It was like a giant weird scab.

Michael Cobb: Watching Will go through treatment, I wondered why the hell you'd put yourself through this physical experience. Really, these cancer treatments bring the body as close to death

as possible and then pull it back. Basically, it's bloodletting. And I kept wondering, why did Will want this? Why would he want to do this? Later on, when I was in hospice on one of those good days, when he actually had other visitors and other people sitting around, he's just chatting and talking and being himself, and I realized, 'Oh, Will just wants to hang out with his friends.' It obviously coheres with his whole practice in life and interaction, but it really did make him very happy.

Lex Vaughn: It felt like no one was doing anything, so I had this fucking freakout. I called a meeting at the Gladstone. There were about fifteen of us. I was like, can we get Team Tumour up, or what? We were all so used to him leading us, or to having him just pop up whenever you wanted him. And I think we were all in deep denial about what was happening, and that it was really fucking serious.

Alex McClelland: There was this phenomenon of people not understanding the severity of the situation. Like, 'Oh, Will's in the hospital. Let's go visit him. It's so nice. I hope he's okay.' They were acting from a place of genuine concern, but I think they also had never seen people die before.

John Caffery: That cancer was so gnarly. It was a long, two-year, horrid battle. And Will was so resistant to the help initially. He was very stubborn. But he eventually opened up to it, and much like he had brought community together so many times in a celebratory way, the community rallied together to provide meals and make sure he was getting to his appointments, and make sure there were logs of everything. There was a real force trying to support him through that.

Cecilia Berkovic: I did a little bit of cooking. Oh my god, he was such a bitch. He'd be like, 'That thing you brought over didn't look very good, but it tasted okay.' And I thought, 'Maybe I'll take you to your blood appointments instead of cooking for you ... Sorry, Mr. Vegan. My vegan cooking skills aren't up to your standards.'

Rori Caffrey: I usually showed up at Will's place with veggie sushi from a takeout place or some salads from Urban Herbivore. A couple times my wife came with me and brought something she'd cooked. He was always gracious and ate most of the food. Sometimes we would sit in his kitchen and chat over dinner, but usually we would take the food to the living room and watch *Ellen* as we ate. I'd talk about work and he'd show me projects he was working on. We did talk about his treatment too. I was scheduled to go for an MRI, my first one ever, and was pretty freaked out about it. Will was all, 'Oh, it's nothing. I've done so many at this point. Just relax and make sure you take out all your piercings.'

Lex Vaughn: We tried to do as many things as we could. That kid loved roller skating. He was a good roller skater. He found so much peace doing that. He loved to go swimming, but his doctor said, 'Hey, man. You need to put on a lifejacket or something if you go in the deep end, because if you have a seizure, you'll drown.' We'd go to this pool near Dundas and Dufferin, where a lot of people would go for rehab, and the water was really warm. I'd put him into a kid's lifejacket and he'd get aquarobics instructions from all the old people.

Peter Ho: Like every other person, he had moments where he looked at his body and was really upset about it, but for the most part he was okay with his body changing, which is a huge deal. It was fun for him, because he'd get to dress more freaky. He'd wear these crazy-coloured outfits all the time. Or this one really disgusting pink nightgown that had a picture of kitten with giant eyes with roses around it. He loved to wear that out. The more sick he got and the more his body changed, I feel like he started transitioning already, like he was not of this world. My favourite moments would be when I bathed him, when he'd just be naked. When you share such intimate moments – like when he had seizures or would throw up in bed or pee in the bed – those are the things that you sort of lose all … I loved him even more because of it. We often said it was like we jumped from a new couple to a couple at the very end of our days, you know? We

lived our lives like that as well. We would stay home and watch TV and craft. Those were his favourite things, anyway.

Cecilia Berkovic: Peter and Will hadn't been dating very long, maybe six months or something, before the diagnosis. And Peter just fucking stuck around. I don't know if everybody would make that decision. Not only did he stick around, but he was Will's primary caregiver and I don't think Will would've lived as long without that. Peter basically gave up two years of his life and prioritized Will's health. They lived together so that Will could be taken care of. He was pretty functional at first, but he could have seizures, so somebody needed to be on top of medication because a lot of stuff would make him pretty foggy. And Peter just took that on, while he was working full-time. And I love him and have deep respect for how well he took care of Will. Will was bitchy before he even got sick.

Peter Ho: He became a very mean person because he was sick. He was very hard to deal with to a lot of people, but never to me, because we had a different relationship from everyone else. I never felt pressured by it, but I think Dave especially loved me so much because he could see that anytime I'd come home from work or visit the hospital after not being there, as soon as I walked into the room, Will was so happy. He changed immediately, and that meant a lot to Dave. I didn't really see it at the time, because that was the Will that I saw. But Dave said, 'He's such a different person around you.' And Will trusted me – he didn't open up about anything to anyone. He was so closed off about his illness, which made it really hard for me at times because I was his only outlet as well. Sometimes at home he would have fits of crying because he was scared of dying.

> *Subject: shitty but promising*
> *From: Lex Vaughn*
> *To: [hidden]*
> *Date: Wed. Oct. 7, 2009 at 7:07 p.m.*

hi all

so ... just after that stupid shunt came out of william's arm and we thought that he was free from doctor bullshit for a spell ...

KABLAMO!

shitty news:

second tumour is not responding to any of the chemo he's been on since may and it's growing very aggressively, so he has to go in for brain surgery on friday morning (goes in tomorrow for pre-tests)

promising news (which far outweighs the shitty)

the new amazing surgeon team is very confident that they can get the whole stupid fucking annoying tumour and put it in a trash can forever!! Apparently it is a sitting duck, and as far as they know, it hasn't wriggled its way to nether regions (fingers crossed!!!). The original tumour is gone, and if all goes well, he could be tumour-free. This is the best-case scenario. Let's hope for this!!!

Will was upset at the timing of the news – as it conflicts with his Vazoween planning. 'Can I go in for surgery after the 30th?' he asked. The doc replied, 'Uhhhh, no. You need to get in here now.' Will: 'Well, this is very inconvenient.'

Classic.

Lex Vaughn: We did the Halloween Vazoween together and he was such a little bitch. He was acting like he wasn't sick. I'd be like, 'Okay, you need to eat! You need to take your meds,' and he'd snap, 'Help me put these pumpkins in here!' He couldn't drive anymore, couldn't ride his bike anymore, which totally bummed him out. Knowing what was happening in his body and him just fighting it so hard ... It was so hard to leave him alone and let him run around, get all the records, do all that shit. All we could do was hang spiderwebs and put pumpkins all over the place.

He was being such an asshole – and goddamn, I don't blame him. He was housebound, he was so sick, he was so frustrated, and he knew he was going to die. He just wanted to throw his fucking party, but it was really hard for him, and it was really

hard to ask for help, and god forbid you don't do something right. We were so concerned about him, and of course he chose the hottest costume on earth, *Stand and Deliver*–era Adam and the Ants, sixty layers of wool. He was just trying to block everything else and live a normal life for a few hours. But as soon as he stopped that night, he came home and had a fucking seizure. He was in the hospital for three or four days after that, and that was the beginning of going downhill.

Subject: here we go again
From: Lex Vaughn
To: [hidden]
Date: Mon. Nov. 23, 2009 at 11:13 a.m.
blech!
so, little willis has been hampered by another infection and is currently in the hospital awaiting surgery.
there are a lot of unanswered questions and a handful of theories about what is happening in that gorgeous brain of his – apparently there is an unnamed fluid that keeps welling up in the cavity left by multiple surgeries and they are trying to find the source of it, but all eyes are on a piece of his skull with an abscess in it. the procedure that they are going to attempt is one where they pull that bone out and scrape/soak the abscess out of it. or replace said bad bone with an artificial one.

we are waiting to find out if that surgery happens today or tomorrow.

for those of you on food, he can't eat today, and who knows about tomorrow – he has not been feeling too well and eating isn't the first thing on his mind. as the week goes on, we will know more about his appetite and when he goes home.

It's time to turn on the golden lasers of healing once again. this kid needs it

Alex McClelland: They had fucked up in the surgery, so they had to cut his brain open again and fix it. They thought, originally, they'd gotten the whole tumour out, that it was a discrete round kind of tumour. And then later on, I remember the doctor coming and describing it to all of us that it was more like a hand. If you imagined a hand with fingers, all interlocking into the brain, reaching in like the brain was jelly or something. So then it was impossible to get it all out.

Lex Vaughn: It was really wild. One of the last times we went to talk to his neurologist about what was happening – when they were basically saying, 'No more surgeries' – she had, up on the screen, pictures of his brain, from the very first surgery through all of the other procedures. She scrolled through and it made this really insane, creepy composite, watching his brain be infested, and then clean, and then infested, and then clean. Basically, every three months, the tumour would reconstitute itself.

Alex McClelland: The doctor came and told us that it was terminal and that they wouldn't be able to get it out. She basically said, 'We can't do anything anymore, so we're going to have to talk about transitioning to a palliative care hospital.' I don't think we all really understood that that meant he was going to die.

John Caffery: Will had really proven in so many ways that we could come together and make amazing things happen, so my spirit believed we could do the same for someone's health, especially with that many people involved.

Peter Ho: There was so much love there. Will was able to absorb it in a different way, and it took him a little while to understand. He was used to always holding up an image of 'Will Munro,' so he didn't know when he got sick what would happen to that. Would people stick around? Certain friends that he thought he was close to, he ended up being not close with them at all. And others stuck around. That was a huge transition, and also for him

to let down his guard, like, 'I don't have to be "Will Munro" around these people. I can just be myself.'

Alex McClelland: Even in the palliative care hospital, we had to be, like, the bouncers, and not let certain people in, which was really fucking stressful and complicated and hard. A lot of people who he knew from the Beaver and doing his nights had this understanding of Will as this very generous, sweet person. They were not necessarily people he would hang out a lot with, but people who understood that they were his friends. And they *were* his friends. But he didn't want a lot of those people seeing him dying, or in hospital with his brain cut open.

Lex Vaughn: We tried to find ways to keep the community working together, creative ways to avoid flipping out – which is what a lot of people did. It's unfortunate. There's a lot of people who couldn't handle it. That killed Will. Not literally – I just mean it broke his heart, that a lot of people couldn't step up. A lot of them couldn't do it till the end, and at that point, he was too far gone.

Peter Ho: I think his last art show [which ran from February 26 to March 27, 2010] was when he realized he was going to die. Planning that show was his way of dealing with death, which was probably harder for everyone else to deal with, because he had already accepted it. We both always said it was easy for us to be together and for me to look after him – the hard part was dealing with other people and how they dealt with him being sick. So his mom, for one, and certain friends. There were a lot of close friends who were around at the start who couldn't deal with it so were not so close toward the end. I think that was hard for him, losing contact. He was a little disappointed with certain people.

Michael Cobb: We were acutely aware over the course of Will's treatment that it was never just the decisions around his own particular immediate care. It was also trying to care for a community that had a lot of desire to be close to him, to feel part of what he's done. And it was Will's doing. You weren't angry about it.

You just had to figure out what would be the best way to move forward, which a lot of us were just improvising. People would waft in and out, with higher priorities and intensity, with the exception of Peter. He was the only one who had to just do it every single day. He had to sleep with it.

Cecilia Berkovic: When Will got sick, people rallied around. I had a car so I would take him to his weekly blood meetings. I got to know his family, and I got to know Dave. Peter had a dream after Will had died, in which Peter said, 'Don't leave me. You're leaving me alone!' And Will was like, 'What are you talking about? I've left you all my friends.'

Alex McClelland: Because he had all this pressure on his brain 'cause of the tumour growing, he would have these amazing moments of being totally gone, and he wouldn't know who anyone was. And he'd have these insane waking dreams, where he'd tell you crazy fantastical stories of ... I don't know, a whole bunch of leather daddies planting flowers together and eating cake, but he would be part of it. We would write down these stories in the book. It made it bearable in a way, sometimes. It was like this beauty of his crazy brain would come out and he'd tell these wacky stories. And then, the next day, he'd be totally lucid and normal and talk to you like he was just himself and it was fine.

Lex Vaughn: At Toronto Western, they'd tried to put him in a coma to relax his brain, and he was so out of it. And when we put him into hospice, he was out of it for a few days and then he came back. He was total full Will. We had Will back for two weeks. It was fucking amazing and really heartbreaking because then he went bye-bye again. But right before he fucking went down again, I was sitting in his room and his brother came in. Dave was like, 'Oh my god. Did you guys read the news about this meteor that's going come in 2018 and obliterate half of Earth?' And Will was just walking back to bed with his little butt hanging out of his nightgown, and he's just like, 'Well, kids, enjoy your meteor. I'll be dead!'

Michael Cobb: There was a really great time in hospice when Will was coherent. Even until the last two weeks, he still would have his really great moments of lucidity and these funny comments that were beautiful and wonderful and heartbreaking. We were talking to Lex, and she had her bike that day, but I remember saying, 'Where's your helmet, Lex?' I'd always make fun of people for not wearing helmets because I've been in bike accidents and my helmets have saved me. And Lex was kind of hemming and hawing, like all hipsters who refuse to wear bike helmets. At that exact moment Will chimes in and says, 'Well, I never wore a helmet, and look what happened to me!'

*

In February 2010, Will mounted one final art show at Paul Petro Contemporary Art, a gallery on Queen Street West. The works included in the show, which he called Inside the Solar Temple of the Cosmic Leather Daddy, consumed Will's thoughts and many of his lucid hours for the months that led up to the opening.

ARTIST STATEMENT:

BEHOLD THE SOLAR ANUS, THE SUBMISSIVE CHAM-BERS OF THE SUN GODDESS, SCORPIO FISTING, THE MEASURE OF SPACE AND TIME, A STALLION BROTH-ERHOOD, THE HALL OF TWO TRUTHS, MOON-RA RESURRECTION, SLAVE BROTHELS OF LIBERATION, RAMRODS, THE FALCONS OF THE COSMIC UNDER-WORLD, MIDNIGHT SUN CONSCIOUSNESS. ETERNAL.

Munro's exhibition Inside the Solar Temple of the Cosmic Leather Daddy combines several of the artist's interests and obsessions. The spiritual iconography of ancient Egypt meets the Queer leather subculture of the 1970s. Through worship and remembrance, Munro revisits the lives lost during the 1980s AIDS epidemic, endows them with a sense of eternal

life, and allows them to still be present among us. Spurred by
his ongoing battle with terminal illness, he has submerged
himself in the underworld of temples and glory holes, death
and transformation, Kenneth Anger, Georges Bataille, Susan
Sontag and King Tut.

Lex Vaughn: He was supposed to have his final show at the Paul
Petro gallery in January 2010. He was *so* excited for it. He had a
lot of people in there helping out and sewing, which killed him –
to have anyone else doing part of the stuff – but he was learning
how to collaborate.

Luis Jacob: I was amazed, after Will got sick, and everything
became just more laborious – it was so difficult to do *anything* –
that he was still working super hard. So I made the offer, 'I've
written a million art grants, so the next time you apply for one,
I'll help you write it, I'll help you edit it, I'll help you put it
together.' And he was like, 'Oh great, because I've never applied
for a grant.' I was shocked! He'd done all of this stuff without a
single dollar of public support. But to me, that was perfect Will,
you know? For him, the art world wasn't an obvious place where
his art *had* to be. It could be *one* of the places, but it had no priv-
ileged role, you know?

Lex Vaughn: Will was working on one of the pieces in that last
show, a giant scarab on denim, but he always did everything the
hardest way possible. For that scarab, he got a photo from a book,
and then photocopied it, and then got one of those tracer lights
from a seventies library, and projected it on the wall, and put
tracing paper on the wall, and drew this giant scarab, and then
put *that* print on a piece of leather, and then hand-cut every single
fucking vein of that scarab's wings. I went downstairs, and Will
was sitting at the table with this tiny little radio that had a speaker
about as big as a quarter, listening to the second side of Patti
Smith's *Horses*. It was so crazy loud and tinny, and he was hunched
over that scarab, cutting these finely detailed wings. He was so
crazed. I put my hand on his back, because I used to massage him

all the time, and he said, 'Oh, yeah! Please!' So I'm massaging him, he's cutting, and Patti is losing her mind. I went deep into that fucking kid's body. I just started to cry. He hated when I'd cry, but I had these hot silent tears streaming down my face. And all this insanity was just streaming up my hands, up my arms, up my back, in my hair.

Peter Ho: I never thought that Will was going to die either. It sounds strange, but throughout the whole time, I just assumed he would get better and we would live and get to hang out. I never thought 'forever after' – I'm not like that. But we shared something really special. He was an amazing boyfriend. He was very caring, very loving. He was such a romantic at heart. He loved cooking for me. I thought he wouldn't be into Valentine's Day because, I don't know, it's not very punk, but I remember coming home from work, and he had bought roses and bought all these dollar-store hearts and displayed them everywhere.

Alex McClelland: He was just bad at talking about himself and his feelings. But he said things every so often about coming to terms with death. He would talk about being dead and what it means, and that's how he started to become really into the spiritual, magical stuff – and not in an ironic way. He liked the idea of spirituality, of something beyond, that wasn't God or anything. Which was what his last art show was about.

Lex Vaughn: He just *had* to finish all these things. It was so hard for him to step back. It wasn't until he got his white blood cell count back up and recalibrated his meds that he was able to take another stab at the show. But I'm glad he did have more time to work on it because he got to think a lot more about what he was making and how it incorporated everything that he was fascinated with at that time. He was so proud of that show. One of his favourite things was when he had that sex sling with the granny blanket and the spider plants, and at one point, all these people's little kids were wrestling and playing underneath the sling.

Luis Jacob: Will told me that when he was little, his mom told him that spider plants purify the air of toxins. And so, to think that the plants in the sex sling – you can imagine they create a kind of oasis of healing, not just metaphorically, but also physically, like they create a space free of toxins and the things that are harmful to your body. And the thing that blows my mind is that spider plants reproduce sexually the way most plants do, by creating seeds and all that stuff, but also asexually, by sending out offshoots that become their own autonomous plants. So, to me, it's an incredible metaphor for how communities sustain themselves and reproduce themselves. Especially queer communities, where we're a culture that doesn't reproduce sexually, like we don't pass our culture to our children. Although, of course, we *do* do that, but in a very different way than heterosexual culture does, because what reproduction means to us is very different. Our children are not necessarily our biological children, and queer people have developed unique ways of connecting generationally as a kind of chosen family.

The show is really about gay culture and a kind of relationship between the past and now. The idea of death and the way it is viewed is something I am thinking about a lot right now. For us, as queers, the eighties was really awful. We lost so many amazing artists and so many amazing queers, and our community doesn't really know how to deal with death and loss. I wanted to present a more positive and hopeful way of thinking about it. I revived some old liberation imagery of triangles and flags, and related them to ideas about how things live beyond death. It's funny, at the opening, there were all these people standing around the spider sex sling installation, and there were little kids playing in it. People kept asking me if it was okay, but I loved it. It looked like some kind of weird worship zone and the little kids playing in it made it totally about life, and worshipping life ...

I am not really interested in Egyptology. I've never been to Egypt. I am white and really have no connection to the culture. But having a terminal illness has forced me to think

about death. The ideas around eternal life and general ways that death was viewed in ancient Egypt made me connect my culture to this imagery. I am into the belief in eternal life after death and myths about people living their whole lives to die. I think about it in terms of remembering, in ways that mark death as not the end of your life, but a kind of beginning. I've also always been interested in magic. I've never been religious. My parents are part of the United Church, but I denounced that at a very early age. I think magic is the closest thing to faith I've had. I am really a believer and I look to it for power.

— Will Munro, from a 2010 interview with friend and care-giver, activist and academic Leila Pourtavaf, in nomorepotlucks

Lex Vaughn: I remember him talking about how, in Egypt, all the pharaohs, their one objective — how they became pharaohs for perpetuity — was to just keep saying their name, saying their name, saying their name. Having their name as some sort of cultural mainstay, through repetition or as a chant. He felt that was kind of what he'd been trying to do with all the people who'd died in the eighties scene, all the queer artists and musicians and

The healing/sex sling at Will's final art show in 2010

creators: keep bringing them around, get them recognized, get them noticed, keep their names and their visions alive.

John Caffery: The art he created in that process was really beautiful. He was looking at different philosophies of what happens after you die. He really connected with Egyptian philosophy and made that really wonderful mirror with a cartouche and the head of a leather daddy. I think he found a lot of comfort and understanding in those philosophies, and a kind of peace within that.

Bruce LaBruce: That whole chapter in Will's life, besides being excruciatingly heartbreaking, it's also the most humbling thing I've ever experienced – the courage that he displayed and his fight, just his grace, having that last show. His whole physical appearance was altered from the chemo, I guess, and he was his same self. I can't imagine how I would respond to something like that, and I would never imagine that I could face it with such aplomb. It just shows what kind of spirit he had.

Peter Ho: Toward the end, during the last few months, when he realized he was actually going to die, he had already planned his death, and he planned how he was going to die and how he wanted people to perceive him. Because of that, he wanted to see fewer and fewer people, because he didn't want them want to remember him as someone who was sick – he wanted people to remember him as Will back in the day. We spent a lot of time together and, yes, I took care of him, but we had such special moments together. Toward the end it was a little harder because while he was sick we would often fantasize about when he got better, where he would want to go, what he would be able to do, and, 'Oh, Peter, I want to take you to Berlin.' It was really nice. Maybe I've just blocked so much of it out, but I don't remember it being extremely unpleasant.

Margaret Munro: He didn't want too many people to know about it, because he didn't want to be identified with cancer. He didn't want that. The circle of friends was amazing. The care was

incredible. The hard part was that I was the one who had authority, and so they'd call me and tell me, 'Will's in the hospital.' Then I'd get down there and the doctor would walk in and they'd all look at me and I'd say, 'I just *arrived*, guys.' That was difficult. But the care was really, really good. The part that was frustrating was that you need a caregiver if you're going to go through the system. The person is too sick to scream for themselves. We had some situations where things happened that weren't supposed to happen.

Michael Cobb: One of the reasons that hospice was so confusing is that the neurosurgeons and the hospice caretakers, the hospice professionals, really have a difference of opinion of what the hospice treatment should be. They more or less wanted Will's body to shut down and die faster. Hospice wants to create as much comfort as possible for people – one phrase was, 'We don't want to interfere with someone's natural process of dying.' And my retort was always, 'Well, then you shouldn't have cut in that first day to take out the tumour.' It's that really weird strange line where euthanasia and treatment get kind of blurry. The major issue was having him on a sodium drip or not. It was astounding. Having sodium in your body can make the world so much better. I was in Los Angeles in April 2010, and started getting phone calls and text messages and maybe emails that were like, 'The doctors think it's any day now.' And this was before he moved to hospice. I dropped everything to come back, and we were prepared for it to happen in short order. But we got there and they put him on the sodium drip, and a day later, he was sitting up, he was happy, he was joking. It was fascinating to watch, but such a mindfuck for everyone. I think this happens whenever you're dealing with these situations. How could they possibly be dying? They're so effervescent. They're normal. Things are going to be okay.

Alex McClelland: Will's parents were not always that great at advocating for his health, but they had power of attorney over him. Given the super stressful circumstances, their responses were understandable. So we had this kind of chosen queer family who would be trying to constantly advocate for him, but we didn't

always jibe with his parents. Often his parents would find out things about his health or the trajectory of what was expected in terms of when someone dies of a brain tumour. They'd have meetings with the palliative care hospital about what to expect. They knew that we were there around him all the time and taking care of him, but they wouldn't tell us what had happened. So there were days where Will would start yelling at you and throw things at you and call you a motherfucker, and accuse you of trying to steal everything from him. Really, really challenging stuff to deal with. A couple of times when that happened, I freaked out at the nurse and was like, 'What the fuck is happening?' She'd say it was normal and that they'd already explained it to the family.

Ian Munro: It was hard coming into the community of care. Even though we were the parents, a lot of the time, when we'd try to join in, the majority of people were sort of like, 'He's ours. He's not yours. He's ours.' And we had a different opinion. But fortunately we were also older. A lot of these people were being supportive but really had no ground rules.

Michael Cobb: I think the people who actually were making the caretaking decisions – because Will partly absented himself from a lot of the decision making – more or less did the best they could at every single point. And the moments of bristling happened when people were slogging through it all the time, and some people were doing less, and some people wanted to do much more. But at the end of the day, it came down to people who felt isolated, frustrated and sad, but were trying to still keep a system going.

Subject: All the single ladies
From: Lex Vaughn
To: [hidden]
Date: Mon. Apr. 19, 2010 at 5:54 p.m.

hi all
its been day three in the wonderful grace hospice facility
(i cant even say the word 'hospital' anymore) and day two

without some of the brain-numbing drugs he has been jacked up on for the last few months – so he has been pretty lucid and funny – is awake for a little longer than three minutes at a time, and today even watched an episode of twin peaks (dark!)

Tomorrow, unfortunately, he gets a roommate, so there are strictly no visitors then, as to let that poor soul acclimate to the round the clock social club that seems to follow Will wherever he goes (be it caretakers or nurses). BUT Will's mom has asked me to send out a group email to visualize a single room for the little man. The nurses think that because he and his community are so young and deserving of the last of his time, that they will apply to the administration this week to try and make that happen. So get out those crystals and start making it real – it will make a world of difference!

Alex McClelland: At the palliative care hospital, we ended up getting him a private room. He first was in a room with this other person, and the night that I stayed in that room was the night the person next to him died, which was really traumatic. When we moved him, we decorated the entire room with all of Will's art, which was really nice, and we put together this, like, shrine for him of all of his crystals. He got really into magic near the end, and the power of crystals. He had a bunch of those salt lights that light up inside. And that's the room he died in.

Rori Caffrey: The last time I communicated with Will was a few days before he died. I'd dropped by the palliative care centre by on my way home from work to visit him. Peter was sleeping beside Will in his hospital bed. I had never seen Will and Peter so close and it was lovely. Peter was on his side, nestled in tight to Will, who was lying peacefully on his back. It was wonderful to finally see Peter sleeping. As Will lay there, eyes closed and breathing slowly, I caressed his hand and wrist. When I stopped, he squeezed my hand and held it. His eyes slowly opened and he looked straight ahead with a glassy gaze. He was not lucid, but didn't look lost or confused either. He looked contemplative

and independent, like a strong man blocking out the world to meditate on the biggest question imaginable. Once Will's grasp loosened, I moved to the other side of the bed, closer to his face, to say goodbye. 'Will, it's Rori. I'm going now,' I said. Will lazily – all his movements were now 'lazily' because of the painkillers – turned his head to look at me. He hadn't been shaved and had thick, bronze stubble, much darker and fuller than I ever would have imagined. It made him look masculine and cool. I bent forward, kissed his cheek, then rubbed his stubble and said, 'I like this on you.' And with that, Will smiled and laughed. The laugh was lethargic and trapped in his mouth, but it was definitely Will's laugh – high-pitched, mischievous and knowing. Will's vision and hearing were failing at this point so it's possible – actually, probable – that he didn't recognize me. The smile and laugh were most likely in response to the tactile pleasure of having his whiskers rubbed.

But in the memory that I'll keep with me always, Will definitely knew it was me, and he was smiling and laughing at a funny memory of me and him in 1996, one that I'd forgotten until then. When I was twenty-four and Will was twenty-one, we decided we'd get electrolysis done on our faces. We wanted to be boys forever. We didn't like facial hair on other guys and hated it on ourselves. There would be so many benefits to having our facial hair permanently removed. We would never have unsightly scruff again; not even five o'clock shadow! And by never having to shave again we would be saving immeasurable time and money – we'd never have to buy or use razors ever again! In my living room in Ottawa, we called two laser hair-removal services from the Yellow Pages for price quotes. One flat-out said they wouldn't do an entire face. The other explained that, although possible, the process would be very long, very painful and very expensive. Obviously, we didn't follow though with it. So when Will looked at me and laughed, I think he was remembering this moment. And had the painkillers not dulled his mouth and tongue, I know he would have reminded me of it, and added, 'And I never did grow facial hair. But look at you, Mr. Lumberjack! I'm unshaven because I'm lying on my deathbed. What's your excuse?'

The crystal-equipped shrine in Will's hospice room

Peter Ho: He was lucid with me until the very end. I think he closed himself off to a lot of people but then chose to share certain moments with me. I would always come in after work – the nurses knew that I was allowed – and I'd jump in bed with him and we would cuddle. That was his most favourite thing in the whole world: to spoon. There was a point in time at the hospital, near the very end, when his mind just disappeared elsewhere. He started saying all these gibberish things that were kind of fascinating. I know it sounds really strange, but it was as if his body was leaving and his mind was recapturing moments in his life. He'd talk about his childhood and certain moments in his life, and project into the future as well, talking about all this cosmic energy and weird things.

Michael Cobb: The last time I talked to Will, I'd picked up some Thai food for him around the corner. I came back and it was the evening. Will was just chomping along, enjoying his food, having this weirdly happy moment. He says, 'Oh, how much do I owe you for the food?' I looked at him, and he had his wallet there as if he's going to pay me some cash, like the old days. I looked around. It was this very strange little moment of, 'This is normal.' And then everyone just leaving and crying. That was the last time I talked to him. After that, he fell into the coma pretty quickly.

Peter Ho: I remember the moment when he was dying, and I remember standing in a circle with Luis, Margaret and Dave. We all held hands and just watched him leave his body. I had never experienced anything like that where you can tell the moment that someone's left their body. They leave and their body shrinks. Everyone left the room and I just had him in my arms, and I couldn't — he wasn't there anymore. I had cuddled in bed with him all this time, even in the hospital. We had shared so many moments together. I just kept holding on to him, and I felt like there was nothing there. He went cold so fast. The body just changed so fast. That was a very strange moment for me.

Cecilia Berkovic: I was at work when Dave called. We'd been in touch with his family so often throughout his illness. I can't remember what he said, but Will had died. I remember going to the bathroom and crying, crying, crying.

Michael Cobb: I immediately went to the hospice and got into the elevator — this elevator was always very slow — and arrived at the top floor. The elevator door opened and they were wheeling Will's body onto the elevator. And the hospice nurse recognized me, and said, 'Oh my god. I'm so sorry.' He was covered with a sheet, but it was this really intense moment. I realized I was probably the last person to see Will's actual physical body. And then I immediately went off to the patio, which was this sunny, bright, lovely space, and found Dave, who gives these insane bear hugs — the most amazing hugs you've ever experienced in your life.

Margaret Munro: Will donated his body to science. He wanted to donate his brain, but they weren't able to. He really wanted it studied to find out why he had gotten cancer. The one thing we were able to donate was his eyes, but I had worried whether his cancer cells, being so close to the eye, would be a problem. My phone wouldn't work that day until it was too late. The time limit had gone by. Every time my phone rang, it was just static. So the decision was made for me.

Andrew Harwood: I was devastated for days upon hearing of his death. I lit candles like a Catholic lady for months after to remember him.

From a Facebook invitation sent to thousands of people shortly after Will's death:

A memorial service/celebration for Will Munro will be held on Wednesday, May 26, at 8 p.m. at the Gladstone Hotel's Melody Bar. All those who have loved and been loved by Will are welcome to attend. The theme is TRANSCENDENCE. Dress it up and leave your shit on the dance floor.

Peter Ho: Will and I had accepted for a long time, maybe a year into his illness, that from that point on, he had two separate lives. We both had to accept that he was a famous person and had to deal with the things around that. I had also accepted that people grieve in different ways. So much of Will is about community that it made total sense to have public memorials. I'm sure that's the theme of everything around Will: community.

Michael Cobb: We'd made an assemblage of different things that were around Will to cheer him up – the crystals and some of his artwork, a whole bunch of little talismans. It really was this huge, gorgeous display of pieces of paper, kind of like if it were an inspiration wall – Queertopia. There it was. The day he died, we had to take all of this stuff down, and it was this really strange moment.

Cecilia Berkovic: People gathered at my house. I think we went to the park for the memorial. I had spent so much time that winter and that spring at the hospice with a core group of people, and it was overwhelming seeing so many people at the park.

Kevin Hegge: I remember hobbling there on my boyfriend's arm. I'm not the most together mourner. I sort of fell apart and was bawling. I only live a block away from the park, but walking there was a nightmare. I had been trying to remain so naively optimistic

to the point of denial that Will would be okay. He had such a monumental effect on me as a person that obviously it didn't seem realistic to have to live without him. It was crazy how many people showed up to celebrate him — so many people you'd see around the city, and have no idea that they too had a connection to Will. His amazing family was there too. In a certain way, Will's illness was really stressful for his community because for the last while he wasn't around and wasn't visible, whereas throughout so much of his illness he was still there — he was DJing right after having his brain operated on! For the time when Will was out of sight and going downhill, people really struggled with that mystery of what was going on, and apart from a small group of people, no one was allowed to see him. I don't remember much more than tears and not being able to talk. It still makes no sense to me that Will isn't here, because he is inherently connected to so much of my life, and so much of the way I know this city.

Rori Caffrey: I biked down to the park. I expected to see a few old friends from back in the punk days, or maybe a few of the great people I'd met through Will's circle of care. But when I arrived, there was a group of people I didn't know but who all seemed to know each other. I started feeling uneasy, like I should've stayed home. Then my wife called. We had both known this day was coming soon, so it wasn't a shock, and I had been composed — glum but composed — since getting Dave's call. She asked where I was, I told her Trinity-Bellwoods, she asked why, I started to explain, and then I choked. I couldn't inhale; I couldn't exhale. I fell off my bike and onto the ground. I was crying one of those hideous cries where waves of tension slam your body, and you open your mouth but nothing — no words, no breath — can escape. I choked out the words *Will* and *died*.

Michael Cobb: It was a really weird disjuncture, having to relinquish caretaking and not being able to be in control. People weren't power tripping about it, it was more just that sense of hunkering down. As the hours ticked by, none of us wanted to go. Then, slowly but surely, a number of us decided, 'Well, maybe ...'

And then somehow, right around the time, most of us got on our bikes and went over. And it turned out to be the most beautiful event. Lex threw fireworks, Roman candles, at people. Margaret came and Dave came, and it was a great moment. The pragmatics of the care of someone, under lots and lots of weird duress, gave way to something else, and we realized, I think, 'Okay, this is now part of a larger thing.' It was exhausting to let go. And then the memorializing had to start happening.

Margaret Munro: It was amazing. We were driving back to where Will lived, and one of David's friends phoned him and said, 'I'm really sorry.' And he said, 'How do you know?' Then we found out about the memorial in the park. It was phenomenal. It was sort of like, 'Should we go?' 'Are you stupid? Yes, we should go.' It was so spontaneous. It was just amazing. We were treated so well. I didn't realize that the owner of the Gladstone, Christina Zeidler, had been one of his teachers at OCAD. They had been so incredibly nice to us. They had put us up when we were down there looking after Will, and they gave us the space for the memorial and it was just phenomenal. It was just amazing. People bent over backwards for us.

Rori Caffrey: I was invited to Will's memorial at the Gladstone and felt really honoured. I understood that a lot of Will's family would be there, so I was concerned about appearing respectful in front of them. I wore a black suit, white shirt and dark tie. I was expecting a sombre event like the ones on TV, where everyone wears dark clothes and talks in hushed tones. In retrospect, I don't know why I had thought that. Why would a Will-centred event be formal or traditional? When we showed up to the Gladstone, people were decorating the room with Will's art and Vazaleen posters. Dave was in shorts and John Caffery was wearing something that looked like a dashiki.

Peter Ho: At the Gladstone, I had to go up and speak. And it was horrifying for me because it felt like being back at the hospital with the sea of people. I mostly wanted to thank people for their care and love during the time Will was sick. What was important to me was thanking all the strong women in his life. That was a huge part of our relationship as well – him as a feminist, him being brought up that way.

John Caffery: After he died, there was a big party at the Gladstone. Will's parents were staying there so that they could be local. A group of us hung so much of Will's art all throughout the second floor of the hotel – his underwear, his fabric works, photographs and all this ephemeral stuff. It was hard to even be in that room. Everything was so fresh and raw. There were pictures from when we first did drag, all our party pictures, his mementoes, the shoes he would wear, his coats ... I found that harder to look at than the works he'd created. It made it that much more real that Will wasn't here anymore, in a living-body way.

Dave Munro: That party was really planned by Will about two weeks before he slipped into a coma. Luis, Peter and I had been helping him leave gifts to people and sorting out his final wishes. He laid out his outline for the party and how he wanted to see it represent his varying club nights. It was entirely DJ-based and we were to make sure it wasn't a glum, mourning kind of thing.

Will wanted a celebration of his life; he wanted people to dance. In classic fashion, after organizing things he looked over at me and said, 'It sucks I'm going to be dead when this happens, 'cause you're going to fuck it up!' The whole thing was emotionally exhausting. It was really crushing. I left that evening covered in tears, sweat and glitter and walked back to Will's old apartment to try and sleep.

Kevin Hegge: I guess one way I got to deal with Will's passing was through DJing his funeral party. They projected pictures of all of us hanging out over the years and somehow, despite the horrible reason for the occasion, it felt pretty festive. Something about the collective anticipation of that night seemed to conjure up the gritty glitter of the Vazaleen days. It was really special. It was sombre but also celebratory – everyone knew how Will would have wanted that night to go down, and it went down exactly that way. I played all the old classics from a decade before: 'Cherry Bomb,' 'Dancing with Myself.' I remember someone mentioned Will once saying he would want to hear 'Heaven' by the amazing queer art band Ssion, so I played that. That seemed like the perfect song in a demented way – and typically hilarious of Will to request that from the other side.

Luis Jacob: For all the sadness, what I remember from the memorials is a lot of beauty coming out. Maybe I'm just speaking from my own little bubble, but it actually felt like this outpouring of love. Just pure love. And that's incredible. People organized a full retrospective of his art at the Gladstone, within three days of him passing away. It happened so quickly at a moment when everyone was so emotionally raw. But it had to happen, all his art had to be brought together, you know? And it was a beautiful show.

John Caffery: All of us, the people who'd put the work up, not only had we just lost this person that we loved, and none of us were sleeping, and we were all riddled with anxiety, but we'd pored through and touched all of his stuff, and that was just so emotionally draining.

Michael Cobb: We had curated a mini-show of his stuff, and it was really an extraordinary thing. And then we had the ceremony for the caretakers and people who had participated and created and helped out, and all the food people, all the various committees were rejoined. But still, even then, there was that weird sense of: there were eight seats. Who got to sit there? Certain people wanted a chair and didn't get a chair. And then you didn't want to be angry at people for caring. I think the chairs were also there for the caretakers who hadn't slept and were tired and basically mounted a show and threw a huge party with no guidance whatsoever except for his scrawled DJ list.

John Caffery: There was a big party downstairs at the Gladstone that night. There was something really transcendent about that celebration – it was so much about his life. I remember having bags of gold glitter and just throwing handfuls on everyone. I remember Luis Jacob playing 'I Feel Love,' by Donna Summer, and getting so lost in it. I remember crying and laughing and crying and laughing with Lex. I remember Peter dancing with such wild abandon that he was actually knocking all the drinks off the shelf behind him with his hair toss, and it was like – who cares? The Apocalypse is nigh! It felt like our world was ending.

Peter Ho: It was liberating. The energy in the room was something I'd never felt before. It was such a huge celebration. I was numb, but I could feel the energy around me and it felt really nice. That was really important to me, to be able to celebrate in that way. Throughout Will being sick, my one escape was to dance. Often, I'd get someone to take care of him and sneak out and go dancing.

Cecilia Berkovic: The memorial at the Gladstone felt very surreal. And I know Will wanted a party or whatever, but I was like, 'I can't have a dance party right now.'

Rori Caffrey: I returned to the Gladstone for the big memorial party. It wasn't my thing. Too busy, too many people. It was

wonderful to see that many people coming out to celebrate Will, but I just don't like crowds. There was a dance party going on in the lounge. When I walked in I saw Alex. He told me that earlier in the night they had projected a slideshow of photos of Will on the wall but had to stop, because instead of dancing and partying, everyone had just started bawling.

Benjamin Boles: Best funeral I've ever been to. Crying on a glitter-filled dance floor. It's weird. It made me think of the stories of the end of the eighties in New York, when that whole post-disco, pre-house scene was literally dying, and the importance of those wakes. Well, when a person knows he's dying, I guess maybe you can talk about someone's death as being part of their larger body of work. I'm assuming he had a lot to do with the decisions about how it was decorated and how it was executed. So in some ways, that wake was his last artwork, and it was beautiful.

Kevin Hegge: The really special musical moment for me was when I cranked 'Fuck the Pain Away' by Peaches. People went apeshit – the dance floor got totally perverted just like back in the day and it was really beautiful in the way that only Vazaleen could have been. Fags and dykes and everyone else just totally losing it and totally fucking the pain away – even straight people! Moments later, we gathered up hundreds of the black balloons that were collected in the ceiling of the space and the whole crowd emptied out into the streets to release them. The whole thing was total elation. It's definitely been a lot less easy since that night. It was a singular moment and totally unforgettable.

John Caffery: We got so many balloons – I think it was a thousand – from Balloon King, and at the end of the night, we sent them all into the sky. It was this kind of release for everybody, at three o'clock in the morning, just watching them all go … up. It felt right.

Luis Jacob: It was such a beautiful moment. And it also reminded me of the subway parties, his birthday parties, because it was so spontaneous. Everyone just went outside, we blocked traffic, we

stopped Queen Street, you know? The balloons were released, and everyone marvelled at this beautiful scene.

Bruce LaBruce: Sadly, I missed his funeral, so I did my own private grieving. Kevin Hegge and I had been at a Lydia Lunch performance at the Bloor, so we were all fired up about that and we went to the park. Will had just died a week before. We were at this particular park bench, very close to where his tree was eventually planted, and we were drinking beer. I had a cornucopia in my backpack: poppers and Ecstasy and probably a little bit of meth and coke. This was before I stopped doing drugs. It was right before the G20 summit. Two cops came over, and they had imposed a curfew in the park that we didn't know about. Kevin is not very fond of cops. I was trying to not get into an incident with them, because I knew they'd look through our backpacks. It just occurred to me that this was part of the loss of Will that was so unfortunate. He was kind of the glue that held together this spirit of resistance against authoritarianism. Having lost him at that moment with the G20 coming up and the whole city becoming a fascist version of the new Harper Canadian identity – it was just doubly sad because he was one of those people who broke all the rules and encouraged people to be freaks and geeks.

*

The G20 horrorshow aside, the spirit of resistance that Will nurtured in Toronto didn't die with him –nor did the legacy of his work. Within months of his death, the Art Gallery of Ontario mounted a show of his work, titled *Total Eclipse*; the Art Gallery of York University followed suit with a stunning career retrospective a year and a half later. A tree was planted; an award to honour community activism through art was established in his name; his family (both chosen and of origin) started a fund to help other queers living with cancer. Dave Munro has carried on his brother's beloved, pain-in-the-ass Vazaleen tradition, putting on a party under the VAZ: Shame banner every year at Pride since 2010 and donating the proceeds to the Will Munro Fund. The

Beaver survives, with some of the same faces, several of the same rambunctious nights, and a new iteration of the same anything-goes ideology. Still, without that glue to hold it all together, the individual pieces can feel haphazard and disconnected, and they carry with them a palpable sense of loss.

Dave Munro: I've tried to keep some of the feelings/visuals of the memorial at the subsequent VAZ parties. I'm not sure if it's out of a lack of creativity or the cold comfort of familiarity. I have found the process fairly tricky due to being so far outside the city; if it wasn't for the dedication of so many people I would run into all kinds of problems. Hell, it wouldn't even be possible. Even my folks drive me around to pick up the odds and sods to get everything in place (that being said, they did the same for Will). I've tried to use people and bands that have been directly connected to Will's shows or had a heavy influence on Will.

Andrew Harwood: I did host the Memorial Vazaleen that Pride to raise money for Will's charity for queer people with cancer. I spent $150 to buy 150 battery-operated tea lights so that mostly everyone would have a little light to remember Will by. When I was onstage, I asked everyone to turn on their faux votives at the same time and asked everyone to chant, 'We love you, Will Munro.' I am rarely without words, but it's all I could think of to say what I felt at the time.

Dave Munro: Most of the events have been very difficult emotionally. You find yourself caught between people who are there out of a sense of memorial and those there for the spectacle. For those who were close to Will, it's still really hard but it's kind of like a comfy sweater. The room is full of memories, mischief and the incredible spirit Will was able to evoke. So even though I feel the parties pale in comparison to what Will created, VAZ still seems to inspire people on some levels, and that's the most important thing. I live in fear of bastardizing what he created. I've been criticized by a few people who say it should just be ended. I have

some seriously thick skin so I can deal with it, but it still sucks. These events are, for me, a way of continuing my brother's love for people and fun, but I'm an outsider to the community on some levels and I never want to have that become an issue. It's a tricky line to walk, so I try to get as much help from Will's close friends to make sure I don't end up being an overbearing asshole force on the event.

Luis Jacob: Everything seemed to happen spontaneously and beautifully. The Art Gallery of Ontario immediately organized a show of Will's work, and the Art Gallery of York University committed to doing a major retrospective. People stepped up and said, 'Of course this has to happen. It's not an idea, it has to *be*!'

John Caffery: It's astounding that all the work in the *History, Glamour, Magic* show at the AGYU was created in a decade – and it wasn't even a complete representation. There were so many posters that weren't exhibited, so many pieces of underwear. You would go out to a restaurant with him and before the food came, he'd be working on creating something new.

Jeremy Laing: It was the first instance of losing someone that I was close to in my adult life. I knew him better than 95 percent of the people who went to Vazaleen, but I feel like everybody felt that same kinship and closeness, even if they had never been friends, or were only acquaintances. And just through the course of life and other projects, we all – well, 'drifted away' sounds dramatic. Turned our focus elsewhere, maybe.

Owen Pallett (friend, erstwhile Hidden Camera, occasional Arcade Fire collaborator, virtuosic musician): Much of the mourning for the loss of Will has also been a kind of mourning for the loss of a scene that has moved on. I remember coming back off an endless Final Fantasy tour in 2006 and saying to Jeremy Laing, 'What happened? Why aren't people socializing like they did in 2003?' and he replied, 'Owen, we all grew up and became adults.' It was true then and it's truer today.

Ian Munro: He was the catalyst, and he attracted – think about the people who were around him, who chose to be around him. There's not a lightweight brain in the bunch. They're all stars in their own right. He had the flavouring, he had the salt, he had the pepper, whatever it was, that made a cohesive whole. And the saddest thing – and I think he was concerned about this – the saddest thing that seems to have come to pass is the plug's been taken out of the drain. No longer is it a cohesive group. And I feel very, very badly about that.

Lex Vaughn: I guess I'm really fucking lucky. I'm lucky because that stuff will never be repeated. I think what will be echoed over and over throughout talking about Will and what happened in Toronto was that inclusiveness. What pisses me off so much about Toronto is that now it's completely returned to its previous state. The same shit's going on. It shows how much power and drive he had. It takes a lot of fucking work to get a bunch of people together harmoniously when they're just happy enough to be completely segregated from each other and being total snots.

Owen Pallett: I worry about Toronto. Kevin Hegge took Will's death really hard. For the year afterward, Kevin was making exclamations like, 'No one can take the place of Will!' with regards to the larger Toronto social scene. But then he told me that he took a look at his accomplishments, and realized that if he was truly going to honour Will's legacy, he'd have to get some more work done – and so he made the documentary [*She Said Boom* about Fifth Column, the legendary all-female Toronto punk band]. The best way to honour Will's legacy is not to cry for him, but to make like him. Will's work ethic was his defining trait.

Kevin Hegge: I do have a lingering paranoia that, as time goes on, we're regressing from all the work Will did to make Toronto's queer scene as unique as it was. More and more you see parties that are aimed exclusively at gay men in the west end, when what made parties like Vazaleen, Peroxide, Xerox and No T.O. so special was the combination of people of different genders,

sexualities, ages and races. There's a very visible erasure of these unique qualities in Toronto's queer scene – it's becoming much more mainstream gay as time goes on, which is really sad and actually just boring. That's a testament to how much work Will actually did to bring people together in a space rather than seeking out exclusive spaces for exclusive types of people. It's not easy!

Peter Ho: I was really fucked up after he died. I didn't know what to do. I just felt like that sense of community really pulled me through. I have so much love for my circle of friends now. That memory of him will always live on. I feel like this year is the first year where I've been able to look back after his anniversary and look at each one of us and think to myself, 'Wow, none of us are fucked up as much anymore.'

Luis Jacob: I think Will gave people gifts, especially when he got very sick. Like, he organized the dance-music party Love Saves the Day with Jaime Sin at the Beaver – a gift he gave to the whole community. I think the phrase 'Love Saves the Day' is a message to all of us to hold on to, something he wanted us to have. And those spider plants from his final show are similar – the spirit of things can continue whether or not he's there. We are the offshoots, and there will be more offshoots after we're gone. We have to be aware that if we don't actively make the things happen, nothing happens. The shoot ends there.

JD Samson: Will and I weren't super-duper close; most of my relationship with him came through his best friends, so I loved him for loving them. He was a special guy who wore his heart on his sleeve, worked hard and made things happen for him and the people he cared about, which meant the community in Toronto. Now that I'm promoting more gigs, I think about him a lot. He was so successful in creating spaces with a mixed audience, and I'm really trying to do more of that too. Overall, his approach to queer space and punk culture has been a huge inspiration to me.

Vaginal Davis: Will was such a dear and there isn't a day that goes by that I don't think of him and that unique accent of his – I like to refer to it as a mid-Atlantic Canuckian patois. No one expressed themselves like Will. He had such an enthusiasm for life and a raucous, experimental spirit. He also had the most beautiful complexion of anyone I have ever met. Just a pretty, radiant youth.

Kevin Hegge: It's funny because it sometimes seems weird to people from N.Y.C. or L.A. or elsewhere that the passing of one artist could be so monumental in Toronto when, historically speaking, art communities around the world have been totally ravaged by epidemics such as AIDS. What people outside don't understand is how difficult it is to operate the way Will did in a city like Toronto – especially when there are no available alternative spaces to work in – the way he managed to take us to surprising and undiscovered territories on a regular basis, and the fact that he seemed to do so without effort. I don't think it was until he passed away that it became evident how unique his vision was in this respect and how singular his work as an organizer was, especially in the context of this city.

Michael Cobb: I think Margaret had a growth experience after Will died, of figuring out what it really meant. Because, like Peter, through the whole process she was realizing this is not just an ordinary citizen. This is actually someone who's a very curious icon.

Margaret Munro: He was a catalyst. In a way, what he brought together was no different than the community we had when we were in Montreal. And the thing is that you always search for that – either to create it, or you look for it. It's a group where there's no superficiality. There's honesty. There's truth in what you say. You can speak from a depth and be accepted. And he was creating that too for people.

Ian Munro: From a very young age, but particularly in adulthood, he exercised choice to the best of his ability. I'm sure he got rail-roaded a few times, those are life lessons. He had his own idea of

normalcy. It was a creation. It was a Toronto he helped create. It's taken me a long time to understand, and I still don't know if I can express it. He was responsible for a lot of things and can accept responsibility perhaps for the ideas, but just about everything he did involved a lot of people. I truly believe he created an environment where the things that were percolating in his mind as desirous – how the Beaver evolved and turned out, how the Vazaleen shows evolved and turned out, working on the call line – from the outside, those look like a bunch of separate things, and at one point in time, perhaps they were. But in his mind, they were just the layers in the cake.

Margaret Munro: His gutsiness was so special. 'I'm going to do this no matter what.' His drive. And his compassion.

Andrew Harwood: I don't think it's possible to sum up Will's life – it's too difficult a task and perhaps too emotional. He was such a special human being.

Luis Jacob: I hope that Will's spirit can see it all. The memorials and everything that I saw was definitely people expressing gratitude and love for him, and their acknowledgement of all the things he gave to all of us, and all the ways he had touched us. It's astonishing that one individual can have given that much to so many people.

Peter Ho: I feel like there was a point in time when Will was sick when he may have already known he was dying, and he spoke about himself as an artist, about the party scene, about the Beaver. And at that point, that was his idea of being remembered – starting that community. In some ways, when he became more sick, he had more time to think about it, and that idea shifted and became more about love and community, his work at the Youthline, his work – I don't want to say as an activist – but more about being accepting of everyone. Toward the end, he was like, 'The freakier, the better.' He always wanted that feeling, which is why he dressed up all freaky. So much about him now is about

his parties. But I think, toward the end, for him it was less about that and more about community.

<center>*</center>

Thousands of years ago, pharaohs believed the secret to immortality was simple: just repeat a name, and the rest will come. Or, to borrow an ancient Egyptian inscription, 'to speak the name of the dead is to make them live again.' There's a profound comfort to that belief that extends far beyond simply carrying the loved and lost in your heart; through a kind of magical-thinking alchemy, they are present in the here and now, weighing in on your bad decisions, spurring you on when inspiration runs dry, eating greasy Singapore noodles with you after last call in Chinatown and laughing at your drunkest, silliest jokes.

There is no doubt that Will's legacy will endure in the minds and hearts and work of those who were lucky enough to be drawn into his orbit. If you visit his tree in Trinity-Bellwoods Park, you're likely to find a collection of strange sacramental talismans: a carved granite pyramid, a drooping flower, a crone-blessed crystal. He is being actively remembered, but unlike the days of his silkscreened posters, constant chatter and nightly DJ gigs, his ideology and influence aren't necessarily absorbed and shared by new recruits to his army of lovers. It's partly chance and luck that Will's life, the more than three-decade period sketched out in this book, coincided with a time of tremendous growth and change for a number of intersecting Toronto subcultures. But that process of growth and change, at least in the spaces he occupied, was also by design – his design. And, vitally, it was communal, active and participatory.

In an essay published in *Xtra!* several days after Will's death, writer and critic Sholem Krishtalka described this weird charmed intimacy, a kind of unconscious kinship that was a given with Will: 'His perpetual superhuman busyness, far from distracting him from people, brought him closer to them; it sprung from a deep belief in the power of community.' The kid was constantly, unstoppably in motion – always in a state of *doing* – but even in

that blur of activity, to be around him was to feel as though you'd found a safe place to land, a sense of purpose, a space to just hang out and *be*. And sure, all this took place in an era of youthful idealism. We were younger and less busy then; we had better metabolisms and more energy, grand plans and the righteous tenacity that's so easily overwhelmed by cynicism and disappointment. But belonging to that community was surprisingly simple: all you needed to do was have a conversation. (Making crafts didn't hurt, either.)

For all the ethereal spirituality of ancient Egypt – the elaborate rituals designed to reunite the life force with its spiritual essence, the mystical qualities of posthumous food offerings – basic repetition feels weirdly pragmatic, almost material. It's active and useful. And when varied experiences of grief cause emotional fissures in a group whose members are dealing with their own personal responses to a collective loss, perhaps saying one thing in ragged unison is a way of mourning together, of feeling less alone.

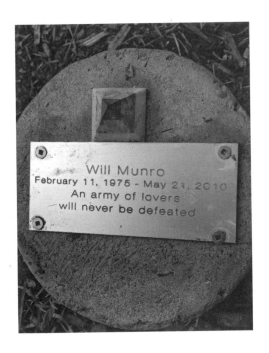

Credits

The photos on pages 15, 17, 97, 109, 113, 115, 130, 136 and 140 are Munro family snapshots and are used with the generous permission of Margaret Munro.

The photos on pages 22 and 25 are school photographs.

The photos on pages 65, 66, 75 and 80 are from John Caffery, used with his permission.

The photos on pages 6, 41, 74, 92, 94 and 100 are from Luis Jacob, used with his permission.

The photo on page 155 is by Sarah Liss.

Page 32 quotes Jim Munroe's article in *Punk Planet* #19, July/Aug. 1997, used with Jim's permission.

Page 45 quotes a *NOW* magazine (June 26, 2003) article about Will Munro by Sarah Liss.

Page 78 quotes an *EYE Weekly* (Nov. 8, 2001) article by Stuart Berman, used with Stuart's permission.

Page 89 quotes an unpublished interview with Will Munro by Sarah Liss.

Page 98 quotes an artist statement by Jeremy Laing and Will Munro for the 2006 show *The Pavilion of Virginia Puff-Paint*.

Pages 120, 122 and 133–4 quote emails from Lex Vaughn to friends of Will Munro, used with Lex's permission.

Pages 129–30 quote an interview with Will done by Leila Pourtavef for the website nomorepotlucks.

The epigraph on page 7 is from 'No Tears for the Creatures of the Night' by Tuxedomoon.

The epigraph on page 13 is from 'Mississauga Goddam' by the Hidden Cameras, used with permission by Joel Gibb.

The epigraph on page 53 is from 'Rock Star' by Peaches, used with permission by Peaches.

The first epigraph on page 105 is from the *Egyptian Book of the Dead*, translated by Normandi Ellis.

The second epigraph on page 105 is from 'Heaven' by Ssion.

Acknowledgements

Thanks to Margaret, Ian and Dave Munro, remarkable folks who are able to find a sense of healing and hope in sharing even their most painful and personal stories. Thanks as well to Alex McClelland, who provided invaluable support and amazing anecdotes. I am so grateful to everyone who agreed to be interviewed for this book, in particular those among Will's Wolf Pack of caregivers: Cecilia Berkovic, John Caffery, Michael Cobb and Lex Vaughn, and Peter Ho, who deserves his own extra-special thanks.

I feel very fortunate to be working with the wonderful team at Coach House, who take such care to produce uncommonly beautiful books. Thank you to Heidi Waechtler, for her close reading and willingness to trek to the ends of the earth (or at least Etobicoke). Thanks as well to Evan Munday, a mensch who is supremely creative and compassionate in everything he does. My infinite gratitude to Alana Wilcox, a wicked smart editor and benevolent overseer who is also very, very funny. And to Jason McBride, whose own work is a reminder of how good writing can be, and whose friendship is as dear to me as his superb editorial guidance: Thank you so much for making *Army of Lovers* exist.

Thanks to my colleagues at *The Grid*, who laugh at my terrible display puns, and especially to Lianne George, who helped shape an early version of the very first section of this book.

I am thankful for my own army of loved ones, without whom this book would not have been possible. Boy wonder Luc Rinaldi, who worked faster than humanly possible to help transcribe these interviews and was an invaluable cheerleader, even from overseas. My bests – Cathy, Danielle, Jackie, Kate, Lindsay – for work dates, pep talks, smoothies and so much more. Tara-Michelle Ziniuk, who remembers all my memories better and more beautifully than I do. My parents and siblings, for everything, always. And, finally, to Lisa, my most careful reader and the rose of my heart.

About the Author

Sarah Liss is the culture editor of *The Grid* magazine and a former online arts producer and feature writer at the CBC. Her writing has appeared in *Toronto Life*, *The Walrus*, *Maisonneuve* and *Maclean's*, among other publications, and onstage at Buddies in Bad Times Theatre and Nightwood Theatre. She lives in Toronto.

About the
Exploded Views Series

Exploded Views is a series of probing, provocative essays that offer surprising perspectives on the most intriguing cultural issues and figures of our day. Longer than a typical magazine article but shorter than a full-length book, these are punchy salvos written by some of North America's most lyrical journalists and critics. Spanning a variety of forms and genres – history, biography, polemic, commentary – and published simultaneously in all digital formats and handsome, collectible print editions, this is literary reportage that at once investigates, illuminates and intervenes.

Typeset in Goodchild Pro and Gibson Pro. Goodchild was designed by Nick Shinn in 2002 at his ShinnType foundry in Orangeville, Ontario. Shinn's design takes its inspiration from French printer Nicholas Jensen who, at the height of the Renaissance in Venice, used the basic Carloginian minuscule calligraphic hand and classic roman inscriptional capitals to arrive at a typeface that produced a clear and even texture that most literate Europeans could read. Shinn's design captures the calligraphic feel of Jensen's early types in a more refined digital format. Gibson was designed by Rod McDonald in honour of John Gibson FGDC (1928–2011), Rod's long-time friend and one of the founders of the Society of Graphic Designers of Canada. It was McDonald's intention to design a solid, contemporary and affordable sans serif face.

Printed at the old Coach House on bpNichol Lane in Toronto, Ontario, on Zephyr Antique Laid paper, which was manufactured, acid-free, in Saint-Jérôme, Quebec, from second-growth forests. This book was printed with vegetable-based ink on a 1965 Heidelberg KORD offset litho press. Its pages were folded on a Baumfolder, gathered by hand, bound on a Sulby Auto-Minabinda and trimmed on a Polar single-knife cutter.

Edited by Jason McBride
Designed by Alana Wilcox
Cover design by Ingrid Paulson
Cover photo of Will Munro's art, untitled, red thread on vinyl, 12" by 7.5",
 courtesy of Margaret Munro

Coach House Books
80 bpNichol Lane
Toronto ON M5S 3J4
Canada

416 979 2217
800 367 6360

mail@chbooks.com
www.chbooks.com